the view camera
operations and techniques

Harvey Shaman

AMPHOTO
1515 Broadway
New York, New York 10036

To Dinny

Library of Congress Catalog Card No. 75-42770

ISBN 0-8174-0598-4

Manufactured in the United States of America.

8 9/90 89 88

Introduction

In the past few years, there has been a resurgence of interest in the view camera and in a more contemplative style of photography. Although the 35mm single-lens reflex is the most popular camera today, the older format view camera is alive and well and gaining acceptance among serious photographers. The reason is readily apparent if you stop to examine the possibilities offered by the view camera:

1. The large format. With it the view camera has the potential for superior technical quality; and with the renewed interest in darkrooms and print-making today, the large format is one of the camera's most attractive aspects.

2. Image control. The truly unique features of the view camera are its slides, swings, and tilts, which give the photographer the capability to control shape, sharpness, as well as perspective.

3. A different way of seeing. View cameras are essentially stationary and nonmobile. This leads to a more thoughtful and contemplative style of photography which imposes a different type of discipline and affords a challenge that is usually ignored when using a smaller handheld camera.

These are the very qualities which almost killed the view camera as a popular photographic tool. It was no pop-it-to-your-eye-and-push-the-button machine, which was what most photographers wanted for seeing and reflecting upon the world around them.

Most people working today in photography are unaware of the shortcomings of their equipment. Their perspective has been warped to the point where leaning buildings and misshapen objects are accepted as normal when seen in a photograph. They may be dimly aware of photographs in which the sides of a building are parallel; or they may wonder how advertising photographs were made, in which kitchen floors appear sharp from the immediate foreground to the farthest edge. For the most part, however, such photographs are viewed either without question or without comprehension.

In the past, the view camera was an awkward and cumbersome device. While these disadvantages have not completely disappeared, the view camera today is a versatile piece of equipment with special backs and film holders, wide-angle bellows, reflex hoods, behind-the-camera controls, and the like. In fact, a vast array of components make the view camera a "system" instead of just a camera.

Although camera models will differ in detail, they are all similar in their controls and operations. They will differ, of course, in the degree of sophistication and quality, depending upon the price, but essentially they are all alike.

This book is designed to clarify the mystery for those who have never understood how a view camera works. For that purpose, we have selected a medium-priced camera that is representative of most of the cameras available today.

In terms of view camera design, there are two basic approaches to the tilts of the camera lens and back. The most widely used is the center tilt. With this design, both lens and film are pivoted around their centers. The advantage is that once the subject is in focus, tilting either the lens or groundglass causes little or no shift in focus, so adjustments are minor. And because the distance between lens and film does not change, there is little variation in general image size.

The second approach to view camera design places the pivot point for the lens and groundglass tilts at the bottom of the lens and film standards instead of at their centers. The advantage of this system is that it allows much greater tilts of film and groundglass than is possible with center tilts. This advantage is counterbalanced by several drawbacks. Primarily, when the lens or film is tilted, the distance between then changes, so it is necessary to refocus. The tilting lens or film also shifts off the horizontal axis, making it necessary to raise or lower the groundglass in order to recenter the image.

There is a third approach to swings and tilts, this around the lens nodal point or true optical center. This approach is extremely accurate and requires a highly sophisticated mechanism.

1 The Equipment

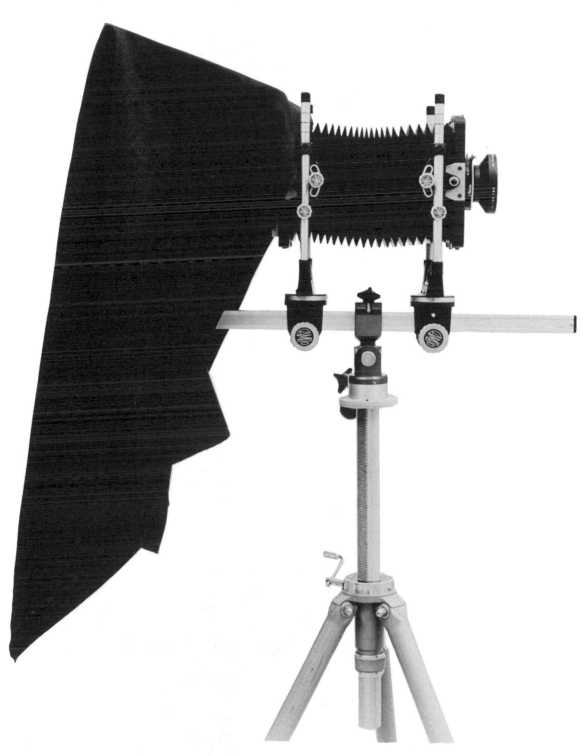

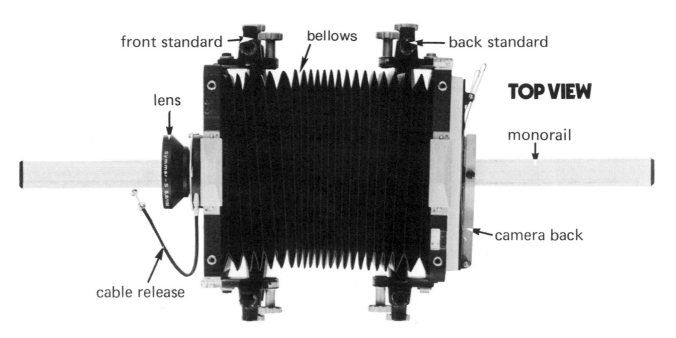

front standard

bellows

back standard

TOP VIEW

lens

monorail

camera back

cable release

FRONT VIEW

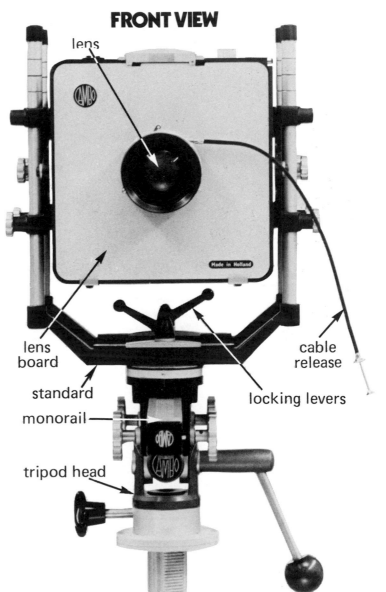

lens

lens board

standard

monorail

tripod head

cable release

locking levers

8

THE CAMERA

The camera shown here is typical of most view cameras. Its principal parts are:

1. **Monorail, or track.** This serves as the basic support structure for the rest of the components.

2. **Front lens standard.** A Y-shaped frame mounted on the monorail, which can be moved and locked into any position on the rail. The lens board is mounted between the upright arms of the "Y."

3. **Back (rear) standard.** This is exactly like the front lens standard except that the camera back is mounted on it.

4. **Bellows.** A flexible lighttight tube mounted between the lens and back standards. This permits the two standards to be moved closer or farther apart for focusing or to accommodate different focal-length lenses while maintaining the lighttight integrity between the lens and the camera back.

5. **Tripod-mounting head.** This holds the monorail on top of the tripod.

6. **Lens.** The appropriate focal-length lens is mounted on a flat plate attached to the front lens standard.

7. **Groundglass back.** A piece of groundglass mounted on the camera's rear standard. The image projected by the lens is brought into focus and composed on this glass. The image will be upside down and reversed from side to side.

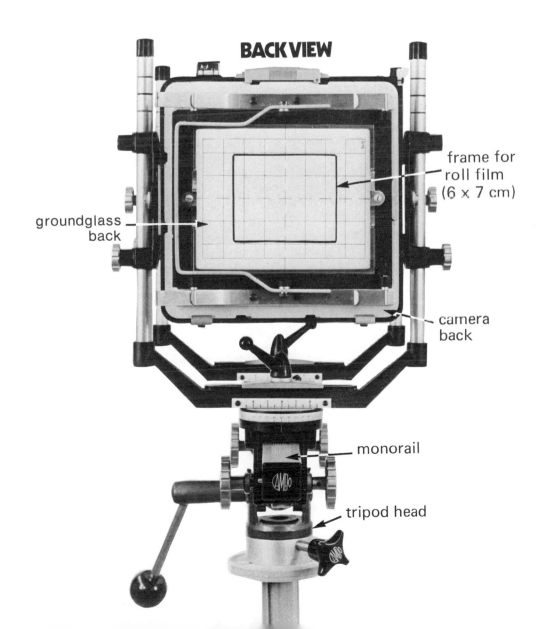

BACK VIEW

frame for roll film (6 x 7 cm)

groundglass back

camera back

monorail

tripod head

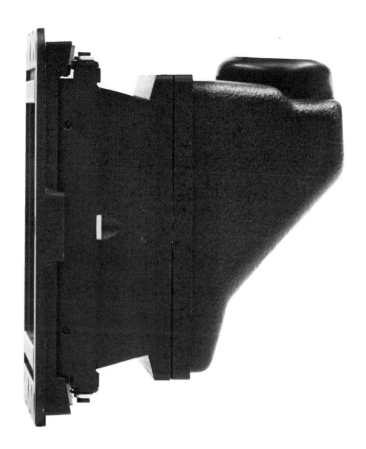

Side view of reflex back mounted on camera (below). Reflex back (right).

BASIC COMPONENTS

View cameras come in a variety of sizes ranging from as small as 2¼″ × 3¼″ to 8″ × 10″ in format and larger. The larger ones are used for special-purpose photography because of their massive size and weight. Essentially, all these cameras are modular, and many of the parts are interchangeable from one to another. They may also be used in combination to enable the photographer to use extended bellows length for extreme close-up photography.

Reflex back. This is an adaptation of the reflex mirror found in standard reflex cameras. It helps overcome one of the most difficult aspects of the view camera by erecting the image so you, the photographer, see it upright instead of upside down as it normally appears. But although the image is upright, it is still reversed from side to side.

The reflex mirror is incorporated into a spring back so it is possible to insert the film holder into the camera without removing the reflex back from the camera. The back can be rotated 90 degrees for both vertical- and horizontal-format photographs. It incorporates a magnifying eyepiece to facilitate focusing and to ease viewing of the groundglass. When such a back is on the camera, it is not necessary to use a dark cloth for focusing as the unit itself serves to keep extraneous light off the groundglass.

Roll-film holder sliding back. This is a combination back which combines a groundglass and roll-film holder in a single unit and is substituted for the normal groundglass. Once the picture is focused and composed on the groundglass, the roll-film half is simply slid into place. One model even has a built-in dark slide that is automatically withdrawn when the film holder is moved behind the lens.

The groundglass is ruled for either vertical or horizontal format. The roll-film holder, which can be detached from the sliding back for loading, has a dark slide. Holders are available in either 2¼″ × 3¼″ or 2¼″ × 3¾″ formats. Attaching the holder in either the vertical or horizontal position determines the photograph's format. The roll-film holders have a single-stroke film-advance lever with an automatic stop when an unexposed frame of film is in position. A built-in frame counter is incorporated in the holder.

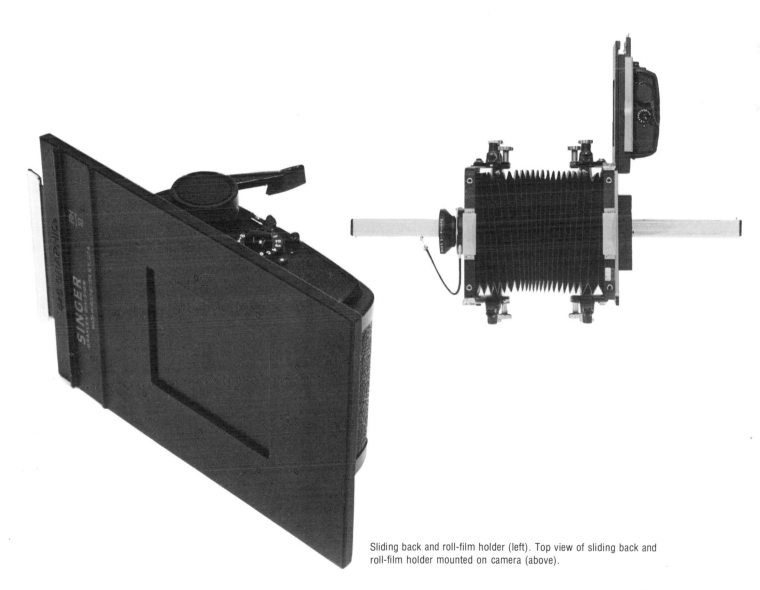

Sliding back and roll-film holder (left). Top view of sliding back and roll-film holder mounted on camera (above).

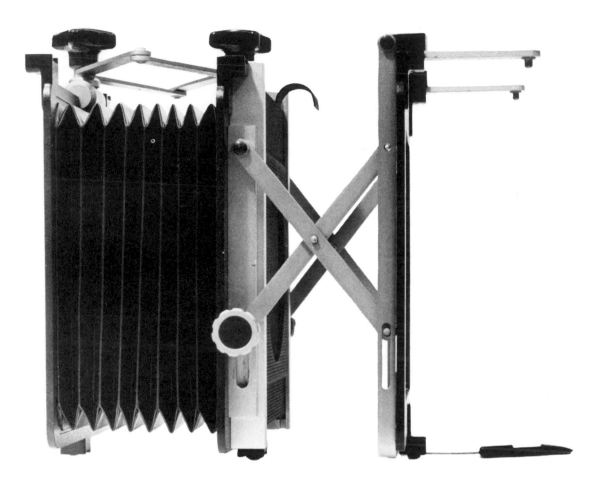

Compendium bellows (top). Compendium bellows attached to front of camera (above).

Compendium bellows. This is a highly flexible lens shade which mounts on the camera's lens board standard. A scissors mechanism at the top of the bellows permits the unit to be twisted in any direction to ensure that the maximum amount of extraneous light is shielded from the camera lens while at the same time ensuring that every part of the subject is in view.

The compendium bellows is held on the front of the camera by simple spring tension. It has a built-in frame to hold the filter holder firmly in place in front of the lens. The mounting arms hold the compendium far enough away from the camera so it is possible to manipulate the diaphragm and shutter without having to dismount it from the front of the camera. A compendium is used to cut down any possible reflections that might degrade the image quality. Close examination of photographs made with and without such a bellows on the front of the camera will show a marked increase in contrast and color saturation of the photos made with the bellows in place.

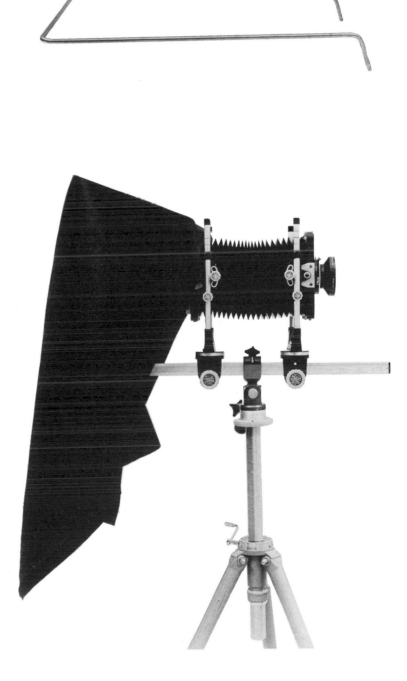

Gelatin filter holder. Filters mounted in this frame are held in front of the camera lens by clamps in the compendium bellows. The holder takes 3″ × 3″ filters for a wide variety of effects, from contrast control in black-and-white to color correction and compensation when shooting color. Several filters may be mounted in the holder at one time.

Focusing cloth holder. This simple wire frame is one of the most useful accessories of the view camera. It clips into the camera's rear standard and a black cloth is draped over it to form a tent around the back of the camera. Without this device, it would be difficult or impossible to compose and focus on the groundglass when working in bright light.

 The reason is simple. Extraneous light reflects off of the unshaded shiny surface of the groundglass, thereby washing out the dim image projected by the lens onto the camera's back. The frame holds the cloth over the camera's back in such a way that the photographer has plenty of room to work while still being in a darkened environment.

Gelatin filter holder (top left). Bracket for cloth viewing hood (top right). Bracket mounted on camera's rear standard with focusing cloth in place (above).

Wide-angle bellows. A short baglike bellows that can be substituted for the normal bellows when using a wide-angle lens. A normal bellows has so much cloth in it that it tends to get in the way when racking a wide-angle lens back to infinity or utilizing the camera's full range of movements.

Short monorail. This is used in conjunction with the wide-angle bellows and wide-angle lenses. A standard-length monorail would get in the way of picture-making when using a wide-angle lens. The reason is simple. If the front and rear standards are set up in the normal manner, then there will be too much of the monorail in front of the lens and it will show up in the photograph. If you move everything forward so the rail no longer shows up in the picture, then the long segment of rail sticking out behind the camera will make it very awkward for the photographer to work.

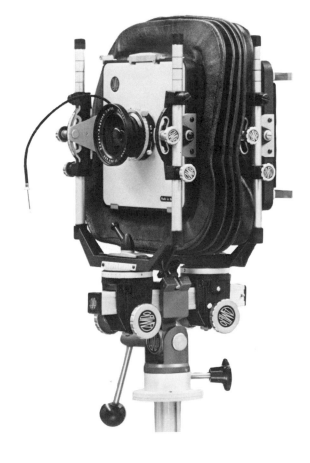

Wide-angle bellows (left). Short track and wide-angle bellows with regular front and rear camera standards (above).

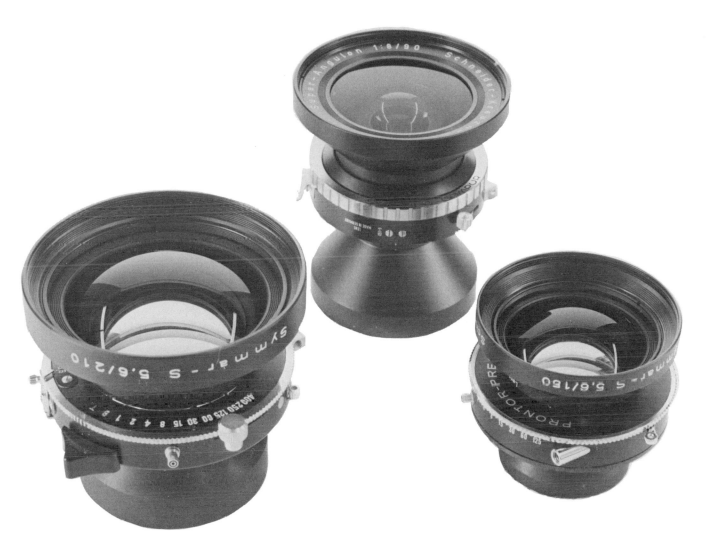

Typical view camera lens selection.

Lenses. The view camera lends itself to full lens interchangeability. The most widely used focal lengths for the 4″ × 5″ are the 90mm wide-angle lens; the 165mm normal lens, which is approximately equal in focal length to the diagonal measurement of the film; and the 210mm long-focus lens, which gives a bigger image and flatter perspective than the normal lens.

The lenses are mounted on lens boards, which are in turn attached to the camera's front standard. View camera lenses are in reality a total unit containing the diaphragm, shutter mechanism, and synchronization connections for both conventional flashbulbs and electronic flash. In addition, most such lenses have a press-focus button, which is a simple lever to open the shutter and hold it open for focusing without having to set the shutter mechanism on time to hold it open.

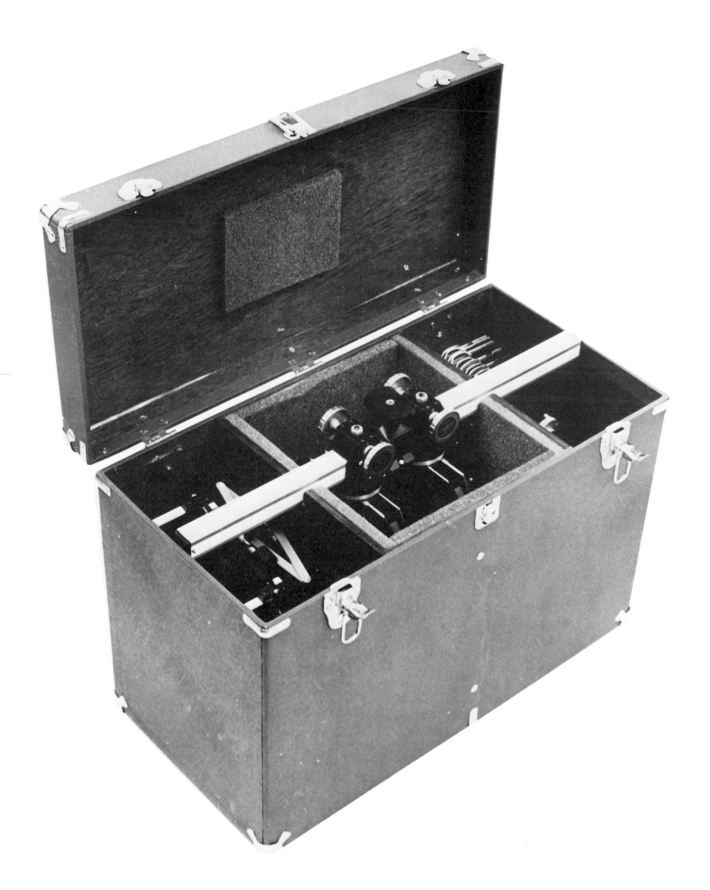

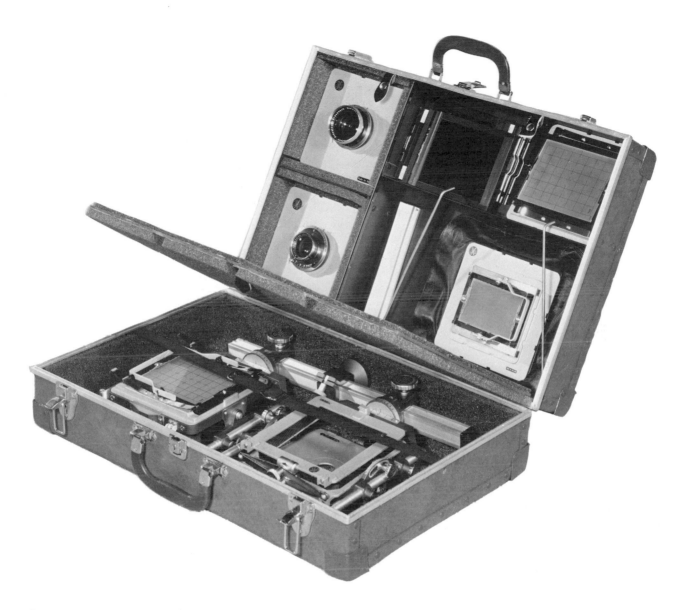

Standard view camera case (left). Suitcase-style camera case (above).

Camera case. Although the view camera is considered a stationary camera, this doesn't mean that it is immobile. A case such as this is an absolute must. It has fitted compartments for the camera as well as spaces for a number of cut-film holders, extra lenses, and many of the other accessories that help make up the view-camera system.

In addition, a case serves both as a means of storaging and protecting delicate photographic equipment. When on location, it serves as a work center, and in emergencies, it is generally sturdy enough to stand on if you must raise the camera up so high that you can no longer see the groundglass. Of the two styles shown, both have advantages and disadvantages. The standard case allows you to store your camera completely set up and ready to go. Its drawback is that it is bulky, and equipment stored at the bottom is difficult to get. On the other hand, the suitcase-type case is generally not as bulky and equipment is more accessible. But to use this case, the camera must be partly disassembled.

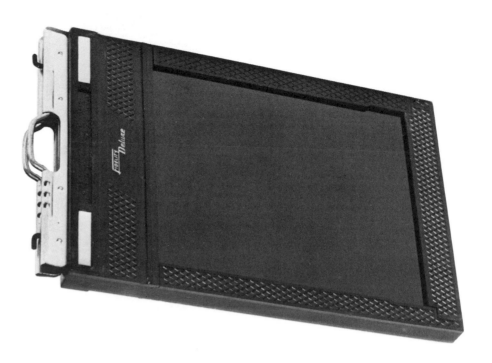

Cut-film holder.

Cut-film holder. This lighttight holder is one of the components that makes the view camera unique. It holds two individual pieces of film, one on each side. A dark slide in front of each ensures that the film is kept lighttight until the holder is slipped into the camera back. The slide is marked so that it is possible to tell if the film in it is exposed or unexposed.

One side of the top of the slide is painted black. The other is silver and has a series of bumps or notches on it. When film is inserted into the holder, the slide is inserted with the silver side out. This indicates that the film is unexposed. After the photograph has been made, the slide is reinserted with the black side out. This indicates that the film has been exposed. The notches or bumps on the silver side of the slide are used for positive identification when inserting the slides in the darkroom after the film has been loaded in the holder. (See Chapter 4 for illustrated loading instructions.)

Roll-film holder. This ingenious device slips into the camera back in place of the standard cut-film holder. It takes a roll of 120-size film and gives ten 2¼" × 2¾"

or twelve 2¼" × 2¼" negatives. The holder has a counter to show exposures made and a dark slide so that the unit can be removed in mid-roll for focusing and composition.

Roll-film holder (sliding back). This roll-film holder is used in conjunction with the sliding back which is available for most view cameras as an accessory in place of the regular groundglass back. In some versions, this type of back may be attached directly to the back of the camera in place of a special removable groundglass, thereby eliminating the sliding-back feature.

Polaroid pack back. This holder will take the standard 3¼" × 4¼" Polaroid film pack. It has a dark slide that slips into the view camera back in the same manner as the regular cut-film holder. The unit contains the standard rollers for instant processing once the exposure is made. A full range of Polaroid films are available in this format. This particular style of holder can be slipped into the back of the view camera in place of a regular 4" × 5" cut-film holder.

18

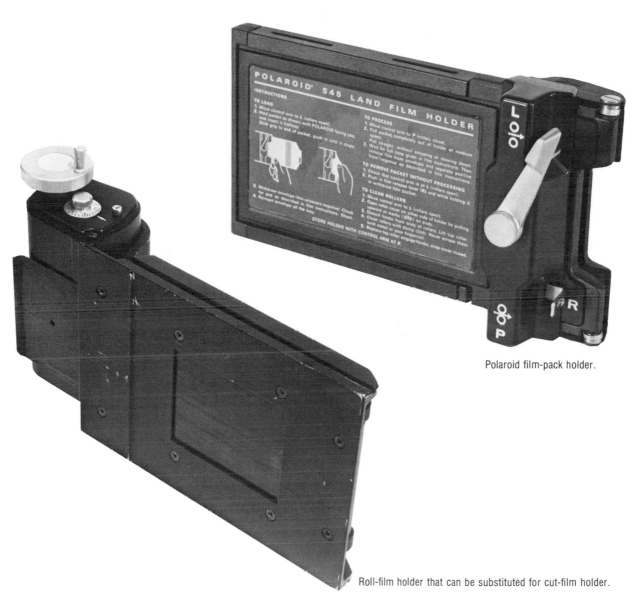

Polaroid film-pack holder.

Roll-film holder that can be substituted for cut-film holder.

Roll-film holder for sliding back.

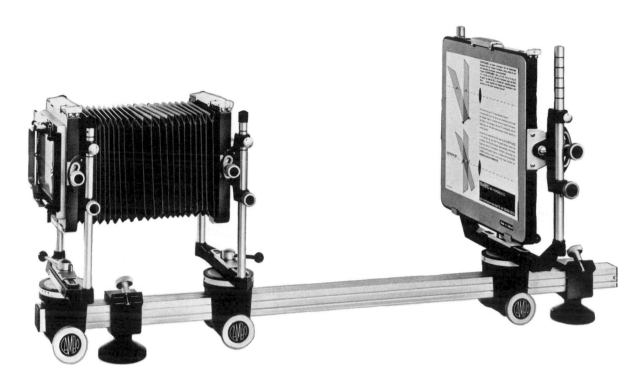

Copy camera arrangement (above). Monopod with 4″ × 5″ camera mounted on the side arm (right).

Copy camera arrangement. One advantage of the modular concept is that it permits the setting up of an optical bench type of arrangement for perfect alignment of components by using an extra-long monorail. The accompanying illustration shows a 2¼″ × 3¼″ camera on one end of the rail and a 4″ × 5″ front standard, fitted with a flat plate to hold the material to be copied, on the other end. Such an arrangement ensures that the material to be copied is square and on the optical center of the lens.

Monopod. A most useful adjunct to the view camera is a monopod camera stand. Such a stand permits the camera to be raised to the top of the stand, or lowered almost to floor level with ease. The stand is on locking casters so it can be moved about easily. Because of their size and weight, such stands can only be used in studios.

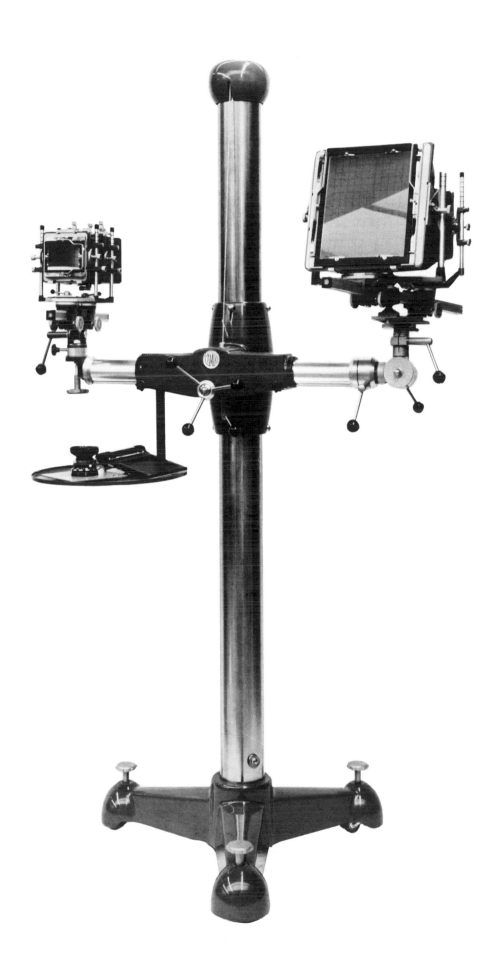

2 Optics

The selection of the appropriate focal-length lens for any particular picture situation is an absolute must if one is to create the desired visual effect. The correct focal-length lens needed for each picture is dictated by several interrelated factors. These are:

Perspective
Image size
Covering power

PERSPECTIVE

The perspective, or size relationships of different objects, depends very much on how far away from each other the objects appear to be when you look at them. If an object is near, it looks large; and if far away, it looks much smaller. This is one of the ways you can judge the distance between various objects when you know the size of each.

If you take two objects of the same size, one near and the other far, then the near one will look larger while the far one will be much smaller. Now if you move farther away from the two, an interesting thing happens. Both objects appear smaller, however the object closest to you decreases in size much faster than the one farthest away. As a consequence, the two objects will appear to get closer together.

The reason for this is simple if you will give it a little thought. Consider the following hypothetical case (see top diagram page 25): You have your camera and two sticks of the same length. Place the first stick in the ground, one foot from the camera lens. Place the second stick 10 feet behind the first one so that it is 11 feet away from the lens. We will assume that you have a normal lens and that the closer stick appears to be ten inches high while the image of the second stick is approximately one inch high.

Now move the camera backward so that it is 10 feet away from the front stick and 20 feet from the rear one. Look at what has happened (see middle diagram page 25): At first there was an 11:1 distance ratio; now the distance ratio is 2:1. The front stick appears on the groundglass slightly over one inch high, almost the same size as the back stick was at the beginning of our experiment. As for the back stick, its distance has not increased ten times as is the case with the front stick; the distance between the camera and the back stick has only doubled. Its size has been reduced to

approximately one-half inch in height. The result is that the front stick is now only twice as large as the back stick where the ratio had been 11:1.

The front and rear sticks appear to have moved closer together. If this negative were enlarged so that the image of the larger stick is again 10 inches high, the second stick would be 5 inches high in the picture, making it seem much closer to the front stick than it was in the previous picture.

This brings us to the first guideline in selecting the correct focal-length lens to achieve the visual effect you want in a photograph.

Position the Camera to Give the Desired Size Relationships Between the Various Parts of the Subject.

In other words, if you want the foreground large and the background small or to appear very far away, then the camera must be close to the front part of the subject. If you want the foreground and the background to be large, or to appear very close together, then you must set up the camera at a considerably greater distance away from the subject.

IMAGE SIZE

Assume for the moment that you have moved the camera away from the subject in order to get the desired size relationships between the various parts. By doing so, however, everything has become very small on the camera groundglass because the lens now "sees" a great deal more subject matter. That is, the lens takes in a great deal more area to the sides and above and below the specific subject area you want in your picture.

This leads to the second guideline in selecting the appropriate lens.

Select the Focal-Length Lens That Gives the Image Size Needed from the Point Where the Perspective Is Correct.

Under some circumstances, you will need a lens that will reach out and cover only that part of the subject which is important, eliminating all the extraneous matter on the sides, top, and bottom, and giving a large, negative-filling image of the subject. Another

way to achieve the same effect would be to shoot the picture from the preselected camera position and then enlarge just the central part of the negative to get the image you want. The drawback here, of course, is that enlarging a small segment of a negative degrades image sharpness and makes the grain structure of the film more apparent. In the latter approach, however, the perspective, or size and space relationships of the various parts of the picture, would be the same, whether you enlarged the center section of a negative or reached out with a long lens and recorded only that center section on the film. Now let's look at a slightly different situation.

Again move your camera to give the desired size relationships between foreground and background. By doing so, however, you don't get enough of the subject to make the picture you need. The solution is to use a lens that gives a greater angle of coverage—a wide-angle lens. The size relationships will remain the same, but the side-to-side and top-to-bottom coverage will be expanded.

COVERING POWER

The image a lens projects onto a very large piece of groundglass is circular in shape. The outer edges of this image are soft, but the major part of the circular image is sharp. Film, however, is either square or oblong. To obtain a usable picture, it must be small enough to fit within this circle. Therefore, the minimum diameter of the sharp part of the circle must be equal to the diagonal of the film.

When a lens is focused at infinity and its distance from the film is equal to the diagonal measurement of the film, then it is called a normal lens. That is, the lens will produce an image on the film that has the same angle of view as the human eye. It will see things just as you and I do. The angle formed by the center of the lens and the two ends of the diagonal is called the *angle of view*. The angle of view for a normal lens is approximately 55 degrees. If the focal length of the lens is shorter than the film diagonal, the lens is a wide-angle lens, and if the focal length is longer than the film diagonal, it is referred to as a long-focus, or telephoto, lens.

Some wide-angle lenses have angles of view of more than 200 degrees. They can literally *see* behind

the camera. For all practical purposes, however, once a lens gets over 100 degrees, there is a tendency for straight lines to be projected onto the film as curves; in such instances, one of the primary features of the view camera, namely, its ability to control the shape of the image, is compromised. Conversely, longer telephoto lenses may have angles of view of five or six degrees or less.

As stated earlier, the minimum diameter of the sharp part of the image circle must be at least equal to the diagonal of the film if the image is to completely cover the film. If, however, you shift either the lens or the film to one side or the other or up or down, part of the film will lie outside the sharp image circle and consequently will be unsharp. If it is moved far enough, the film will lie completely outside the image circle and will get no exposure at all.

And this leads to the third guideline in selecting a lens for use on a view camera.

In Order to Use the Slides, Swings, and Tilts of the View Camera, It Is Necessary to Select a Lens That Projects an Image Circle Greater Than the Diagonal of the Film. This is Called "Covering Power."

With a 4″ × 5″ camera, the diagonal of the film is approximately 6½ inches, and a 6½-inch focal-length lens will produce a normal image—one that has the same angle of view as the human eye. If this sharp image circle is *only* 6½ inches in diameter, any sidewise movement of either the film or lens will immediately put part of the film outside the usable image circle. It is therefore necessary to select a 6½-inch focal-length lens that projects an image circle larger than 6½ inches. A circle of approximately nine inches in diameter is considered adequate to handle most camera movements. Keep in mind that both of these are normal lenses in that they both produce an image which gives the same angle of view as the human eye. The difference is that one gives more side-to-side coverage than the other.

In buying a lens for view camera work, be certain that it has adequate covering power, generally expressed as *angle of coverage*, to permit use of the swings, tilts, and slides. View camera lenses should have at least a 70-degree angle of coverage if full camera movements are to be utilized.

24

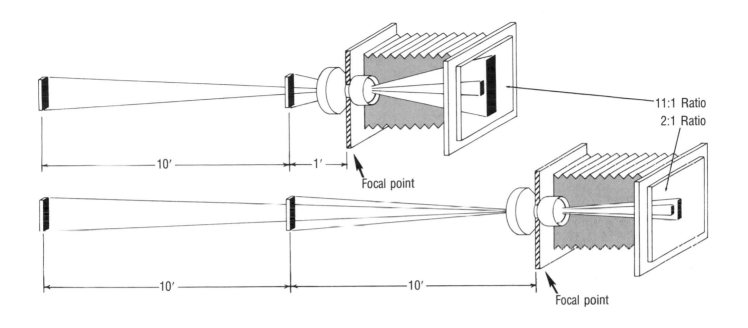

11:1 Ratio
2:1 Ratio

Focal point

10′ 1′

Focal point

10′ 10′

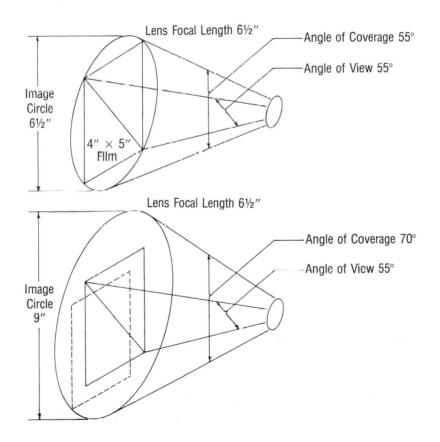

Lens Focal Length 6½″

Angle of Coverage 55°

Angle of View 55°

Image Circle 6½″

4″ × 5″ Film

Lens Focal Length 6½″

Angle of Coverage 70°

Angle of View 55°

Image Circle 9″

PHOTOGRAPHIC FACTS OF LIFE

Once the decision is made to use a lens of other than normal focal length, there are a number of factors you should be aware of in order to get the optimum performance out of the selected lens.

LONG LENSES

Space compression and size distortion. Because of the ability of the longer focal-length lens to reach out and pick up an image at a distance, the spatial relationships between the near and far part of the subject are distorted, producing a compressed or flattened visual effect.

In some cases, this distortion is advantageous. In others, it creates effects the human eye would ordinarily never see. In portraiture, for instance, it is standard procedure to select a lens of at least double the normal focal length because it lets you get a negative-filling image without being right on top of the subject; this reduces the size of the subject's nose. With a normal lens, the camera would have to be extremely close to the subject to completely fill the negative; this would have the opposite effect, distorting the subject's nose and making it appear larger than it actually is.

We have all seen photographs where a huge sun is going down behind a familiar object. In such cases, an extremely long lens is used to compress the space between the sun and the object so that the relative size of the two is completely distorted.

Vibration and camera movement. Most cameras are mounted on a tripod by a single screw located approximately under the center of gravity so that the entire unit balances. As the focal length increases and the lens gets farther from the film, there is a tendency for the center of gravity to move forward of the tripod-mounting screw. The result is that the added weight at the front of the camera will tend to pull the front downward, thereby causing the entire camera-tripod combination to become unbalanced. There is also added tension on the tripod's tilting mechanism and a subsequent tendency for the whole assembly to either move or be subject to random vibrations if someone walks across the floor or, if outdoors, if the wind blows. While it is possible with most view cameras to shift the tripod-mounting socket so that it remains under the center of gravity, there is still an increase in the total length of the camera and therefore a greater possibility of movement during the exposure.

Working room. One of the constantly recurring problems with long lenses is having enough physical room in which to use them. It is often necessary to move the camera so far back in order to keep the image the proper size and give the desired perspective that the camera is all the way back to the wall and you have no room to get behind it to focus or insert the film holder. Sometimes you are forced to back off through a doorway into the next room or to go outside and shoot in through a window. The real problem is finding a tripod tall enough when your studio happens to be on the fifth floor.

Even with moderately long lenses on a 4″ × 5″ or 8″ × 10″ camera, the problem of shooting down on your subject can become acute because tripods are either not tall enough or the studio ceiling is not high enough. This is the point where you have to start making compromises by either using a shorter focal-length lens, which lets you move closer to your subject but also changes the perspective, or by going to a smaller format and readjusting the spatial relationships between different parts of your subject.

Narrow angle of view. Another very definite consideration is that the longer the focal length, the narrower the angle of view. With a narrow angle of view, it may be necessary to back off a great distance in order to get the entire subject in. If you are very far away, you may get an undesirable compression effect, such as making the background too prominent in relationship to the foreground, or if you are dealing with people, they may be so far away that you have difficulty telling them what you want them to do.

Limited depth. At close distances, long focal-length lenses have extremely limited depth of field. This can be great if you want to isolate a single subject from a large mass, because it can be sharp while everything around it is out of focus. But if you need depth because both the foreground and background are equally important, such as in a double portrait where one

person is standing slightly behind the other, you have problems.

Slow speeds. Most longer lenses are not high-speed optics; $f/4.5$ is considered fast and $f/5.6$ or $f/8$ are more nearly the norm. This is fine where lots of light is available or you can illuminate your subject; but under less than ideal lighting conditions, it can make for difficulty when focusing on the groundglass and most certainly for long exposures with the consequent danger of camera movement because of the extensive leverage inherent in the physical size of the camera-lens combination or subject movement from any one of a dozen causes.

WIDE-ANGLE LENSES

Linear distortion. Parallel lines tend to converge at a distant point when either observed or photographed. With wide-angle lenses, particularly extreme wide-angle ones, this convergence becomes excessive, resulting in either a disturbing visual effect or so distorting the image that it is difficult to visualize how the object actually looks. When photographing nonlinear subjects, such as people, the resulting distortion can produce large misshapen heads or make other parts of the body appear wildly out of proportion.

Distorted perspective. Because of the short focal length of a wide-angle lens, it is often necessary to get in extremely close to a subject to make the image large enough. As a result, the distance relationship of the lens to the front part of the subject as compared to the distance relationship of the lens to the back part of the subject is such that the perspective is completely distorted, making the back appear much farther away from the front than it actually is.

Dim groundglass. Because of optical design problems, wide-angle lenses tend to have relatively small maximum apertures. The small aperture coupled with the large physical area of the view camera groundglass results in a very poorly illuminated groundglass. Consequently, there is difficulty both in composing and focusing, particularly at the sides and corners of the groundglass.

Circular objects. Because of the distortions in the distance relationship between the front and back part of a subject, circular-shaped subjects are affected in two ways: they become oval in shape; and the oval tends to tip at an angle. This dual distortion becomes more and more apparent as the circular shape gets closer to the sides or corners of the groundglass. The general solution in handling such subjects is to try to position them as close to the center or at least as close to the central axis of the photograph as possible.

Camera bulk. Wide-angle means a short focal length, which in turn means that the lens must be relatively close to the groundglass when focused at infinity. View cameras tend to be large and bulky, so much so that the combination of back standard, bellows, and front lens standard makes it impossible for you to move the lens far enough back to focus at infinity. There is too much camera in the way, particularly if you want to use the swings and tilts.

To get around this disadvantage, cameras with interchangeable bellows resort to a bag-type of bellows with considerably less material in it as a substitute for the normal accordion-type bellows. For cameras with noninterchangeable bellows, it is necessary to resort to a recessed lens board to hold the lens-shutter combination. With such a recessed board, camera controls may be difficult to reach. And if the diaphragm and shutter settings are on the side rather than at the front, they can be impossible to read. If the shutter and diaphragm levers have click stops, you can memorize these and work blindly, or do as I do and carry a dentist's mirror to slip into the small spaces and read the settings.

3 Focusing

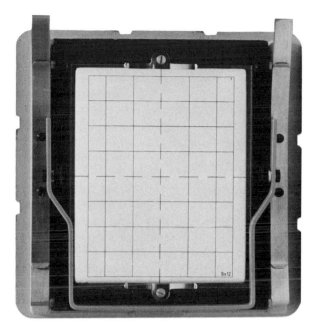

Groundglass of a modern view camera.

The large groundglass on which you can compose and contemplate the image until it is precisely the way you want it makes the view camera a pleasure to work with. Due to its size, you can examine and control details within the picture that would either have to be skimmed over or completely ignored because you couldn't really see them if you were working with a smaller camera. With the view camera, you have precision and control in a manner and to a degree that cannot be imagined when working with handheld cameras.

However, this same groundglass can cause a degree of frustration bordering on paranoia simply because of the manner in which it presents the image—*the image is inverted*. It is both upside down and backward, that is, reversed from side to side. As a consequence, you must learn to function backward if you are to successfully manipulate the camera's controls. If you want to move the subject, it must be in the opposite direction from that presented on the groundglass. If you want to manipulate the camera, then the controls must also be moved opposite from the way you normally would.

When you look at something that is both upside down and backward, it becomes very difficult to sort out and understand exactly what you are seeing. As a matter of fact, after more than 30 years as a photographer, I still catch myself trying to stand on my head in order to fully understand details in a complicated setup.

Let's consider the groundglass for a moment, because its size is such that situations which seldom crop up when using smaller cameras must be taken into account. A groundglass is a piece of glass or plastic that has been frosted on one side. The frosted side is inside the camera and is the one on which the image is brought into sharp focus. The back, or outside, of the groundglass is smooth and shiny like any other piece of glass.

Because a groundglass is flat, there is considerably greater distance from the lens to the corners than from the lens to the center. The light, having farther to travel, becomes more dispersed; as a consequence, the image is considerably brighter at the center than at the corners of the groundglass. Because of this factor, it may be difficult, with some very slow lenses or when focusing with the lens stopped down in order to judge depth, to see the image clearly, particularly at the corners.

To compound the difficult problem of seeing the image, there is the reflective quality of the shiny side of the groundglass. It will reflect any light that happens to be behind the camera; this in turn washes out the image, making it almost impossible to see. To get around this problem, the photographer usually drapes a piece of opaque black cloth over his head and over the back of the camera. This creates a tent which excludes most of the extraneous light.

An extremely useful accessory available for some view cameras is a wire frame that attaches to the back of the camera and over which is draped the black cloth. The frame holds the cloth up and out of the way so that the photographer can more easily move his head around to get a better look at the groundglass.

When working under the focusing cloth, there is a tendency to get the face fairly close to the groundglass and to look at only a small area at a time. Sometimes it helps to move the head away from the groundglass, while still remaining under the black focusing

cloth. This gives a better overall view and aids in judging relative brightness.

To overcome the problem of uneven light distribution across the groundglass, a Fresnel-type lens is available as an accessory. This flat lens is designed to go in front of the groundglass and is so shaped that it projects more light toward the corners than toward the center. The effect is to even out the illumination so that the image is not only brighter, but also more uniform across the entire groundglass. This aids in both composition and focusing.

However, the textured pattern of the Fresnel lens creates problems in that it breaks up the image, making it unsharp on the groundglass. For this reason, the center of the Fresnel generally has no ridges on it; the image can then be seen directly for more precise focusing.

In focusing, the pebbled texture of the groundglass also tends to break up the image somewhat, so it is difficult to tell if it is precisely in focus by simply looking at it on the groundglass. The usual technique for focusing the camera is to rack the lens back and forth until you can stop at precisely that point where the image appears the sharpest. An aid in doing this is the knowledge that the point of sharpest focus is where the converging light rays from the image come together. This means that at the point of sharpest focus, the image will be at its brightest. As a matter of fact, under very dim lighting situations, it is often easier to focus for greatest image brightness than for greatest image sharpness.

A technique some photographers use to get a brighter image on the groundglass is to cover the rough, or ground, side with a very light coating of oil. This coating fills up some of the pebbled surface of the glass, resulting in a smoother texture that is brighter, thereby allowing for finer focusing. The drawback here, of course, is that dust and dirt are attracted to and tend to adhere to the oily surface of the groundglass. This dirt may fall into the camera or get on the film when the holder is inserted.

A very distinct aid in checking details, both in terms of sharpness and for composition, is an auxiliary magnifier that can be held directly against the groundglass surface. Such a device is generally undirectional

in that there is one flat glass surface which must be placed against the groundglass in order to make it work. If you reverse the magnifier, nothing will come into focus.

Most cameras have lines scribed on the groundglass to aid in composition and for control of alignment where parallel lines are to be kept parallel. Some use a ½″ × ½″ grid pattern while others have vertical and horizontal centerlines.

With many cameras, you will find that either one or all four corners of the groundglass are cut off. Generally, if only one corner is cut, it permits air to move in and out of the camera. This equalizes the pressure when the camera's spring back is pulled out to make way for the film holder. If pressure is not equalized, a partial vacuum could result inside the camera, which might either cause the bellows to collapse or, if sufficient pressure is exerted, cause a shift in the camera's focus.

Where all four of the corners of the groundglass have been cut, they serve as viewing ports to make certain that nothing is in front of the lens. Quite often in studio setups, a compendium bellows is attached to the front of the camera to shade the lens from the lights and to serve as a filter holder. This compendium is adjustable for shading a number of focal-length lenses and can be pulled far enough forward so that it cuts into the picture area. By looking through the four cut corners of the groundglass, it is possible to tell if the compendium or anything else is intruding into the picture.

A device that has become available only in the last few years is a reflex back which can be substituted for the normal camera back. This permits you to look down into the camera in the same way as with a standard reflex camera. The advantage is that the image no longer appears upside down, and it is much easier to both compose and decide on the correct point or plane of focus.

Despite the usefulness of the reflex back, there are certain characteristics of which you must be aware. Primary is that the image is reversed from left to right just as it was on the groundglass. This can be confusing, but it is, in reality, minor. A secondary consideration is that the viewing for such a reflex

finder is generally through a centrally mounted eyepiece, so it is difficult to see the corners of the groundglass. All in all, however, reflex backs are extremely useful, particularly when setting up a complex picture.

PLANE OF FOCUS

Deciding on the correct point or plane of focus is a primary consideration in making any photograph with any camera. It is paramount in working with the view camera because one of the major features of the view camera is its ability to let you place this plane with precision. The camera's swings and tilts let you shift this plane of focus away from the vertical so that it can be made to correspond to the areas of greatest importance in the subject. Remember, once the plane of sharpness has been decided upon and the camera back or lens has been swung to position it, stopping the lens down will increase the area of sharpness.

As with any other lens, the overall depth of field of the view camera lens is very much controlled by the size of the aperture; the smaller it is, the greater will be the depth. The appropriate technique is to select a point approximately one-third of the way into the subject upon which to focus. The resulting area of sharpness will be twice as deep behind the point of focus as in front of it.

FOCUSING BACK AND FRONT

With all small cameras, the camera body is held steady or mounted on a tripod and the lens is moved back and forth until the image comes into sharp focus. Not so with the view camera. With any view camera, both the front and the back can be moved on the camera's track, or rail, which is mounted on the tripod head. Therefore, either the back or front can be moved to focus the image.

The image size of any camera is determined by the lens-to-subject distance. With most smaller, hand-held cameras, moving the lens causes only slight changes in lens-to-subject distance and has little effect on image size, for all practical purposes. With the view camera, however, the normal lens has a focal length of six inches for the 4″ × 5″, so the change in lens-to-subject distance can be appreciable, particularly when focusing on a closeup subject. Therefore, correct technique calls for setting up the camera so that the lens is at the proper distance to give the desired image size. Final focusing is done by moving the camera back while the lens-to-subject distance remains constant.

MOVING RAIL

For greater control if the camera is either a little too close or too far away from the subject, the simplest way to adjust the distance is to slip the rail back or forth through the tripod-mounting bracket. When possible, the adjustment should be done this way rather than by moving the tripod. In this way, a carefully composed image on the groundglass is not disturbed because the movement is along the camera's central axis. Shifting the tripod would also entail having to raise or lower the camera with all the problems of trying to get the image aligned the same way it was before.

CHECKING DEPTH

A final point in focusing is to check the depth of field. This is done by stopping the diaphragm down and looking at the image on the groundglass. However, you will find that if you stop the lens down and then look on the groundglass, particularly at very small apertures, it will be practically impossible to see what has happened. The proper technique is to get under the focusing cloth with the lens at its widest aperture. Then reach around in front of the camera and slowly pull the lever, closing down the diaphragm. It takes a certain amount of practice to locate and operate the diaphragm lever while standing behind the camera, but it is the only way the operation can normally be done unless you have the luxury of either a camera with diaphragm controls located at the back of the camera or an assistant who can do it while you look at the image on the groundglass.

When you get the depth you want, stop closing down the diaphragm. By stopping a lens down gradually as you watch, your eyes become accommodated to the decreasing amount of light being transmitted and give you extremely accurate control of depth.

4 Film

LOADING PROCEDURE

Most view camera pictures are made on individual sheets of film rather than on rolls such as are used in 35mm, 2¼, and other roll-film cameras. The standard sizes for sheet film are: 2¼″ × 3¼″, 3¼″ × 4¼″, 4″ × 5″, 5″ × 7″, 8″ × 10″, and 11″ × 14″. The two most widely used sizes are the 4″ × 5″ and the 8″ × 10″. For the most part, 5″ × 7″ and 11″ × 14″ are used only in special applications, and for film sizes smaller than 4″ × 5″, there is a tendency to use roll film in special holders.

Sheet film is inserted into the camera in a two-sided holder. Each side is covered with a dark slide that makes the holder lighttight. The slide is removed after the holder is inserted into the camera.

The following illustrations show how a cut-film holder is cleaned and loaded.

1. Loaded holders. The top holder contains unexposed film (silver side of slide faces out) while the bottom one has film on which a picture has been made (black side of slide faces out). Note the latches on the end of the holders; these prevent the slides from being pulled out accidentally.

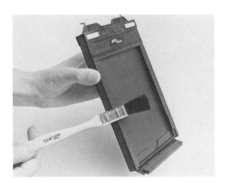

2. Cleaning the film holder before each use is essential because the smallest particle of dust inside the holder can cause a scratch or a pinhole, which would appear as a dark spot on the final print or transparency. To clean a holder, remove the slides, open the flap at the bottom, and tap the edge of the holder sharply with the edge of the cleaning brush. This dislodges dust particles which may have become trapped in the slot at the top of the holder through which the dark slide is inserted.

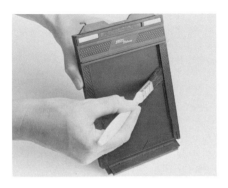

3. Carefully brush out the entire interior of the holder on both sides. Take particular care with the edge grooves that will hold the film in place when it is loaded. An ordinary small-bristle paintbrush does the job well.

4. Use a soft cotton cloth or handkerchief to wipe the dark slide clean.

5. From this point on, you will be working in complete darkness to avoid exposing the film. To load film, open the film box, which consists of a top, bottom, and a second bottom inserted in the first. The three parts of the box make a completely lighttight film container. In addition, the film is sealed in a foil envelope. (Film usually comes packed 25 sheets to a box). Open the foil envelope from one end so that the unused sheets of film can be reinserted for storage. For positive identification of the emulsion side of the film while working in the dark, there are a series of notches in the upper right-hand corner of the sheet. When the film is held in the right hand in the manner illustrated, the emulsion side of the film is up. Each emulsion type has a different series of notches, so it is possible to tell exactly what type of film you are loading into the holder.

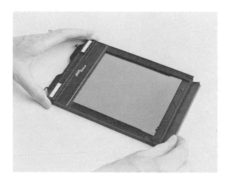

6. The left thumb and forefinger are used to guide the edge of the film into the grooves on each side of the holder. These grooves keep the film flat and in the proper position in the holder. Note that the emulsion is up, facing toward the open side of the holder, which will later be covered with the dark slide.

7. Once the film has been pushed completely into place, it is wise to slip a fingernail under the end and try to lift it up. This is to ensure that the film has actually slid into the grooves on each side of the holder. Finally, close the flap at the bottom of the holder, which holds the fourth edge of the film flat.

8. The dark slide that is inserted into the holder to keep the film lighttight, until the holder is put into the camera, has a silver as well as a black upper edge. After the film is loaded, insert the slide with the *silver side out*; this indicates that the film is unexposed. To facilitate insertion in the dark, a series of easily felt notches are on the silver side. Once the picture is made, reinsert the slide with the *black side out*; this indicates that the film has been exposed.

9. Slip the dark slide into its slot in the holder and push it all the way into the groove in the bottom flap. Be sure the silver side is out, and that the end of the slide seats properly in the flap.

Exposure Increase Needed for Various Degrees of Magnification

Magnification	Amount of exposure increase	Number of stops needed for required exposure increase
¼:1	1.5	½
½:1	2	1
¾:1	3	1½
1:1	4	2
2:1	9	3
3:1	16	4
4:1	25	4½
5:1	36	5
6:1	50	5½
7:1	64	6
8:1	80	6¼
9:1	100	6½
10:1	120	7

Note: When using long exposures check the reciprocity effect of the film being used.

EXPOSURE INCREASE

A consideration in any photography, one that most often comes into play when using the view camera is the bellows factor. This is the amount by which exposure must be increased over what is called for by the light meter in order to correctly expose the film.

The closer you bring the camera to an object, the smaller will be that part of the object which the lens will see and the larger that particular segment will appear on the camera's groundglass. This means that the light being reflected from this small segment must now be spread over the entire sheet of film instead of being concentrated onto only part of the film as it would be if the camera were farther back and that particular segment occupied only part of the picture instead of the whole thing. The result is that there is less light striking any one segment of the film. In order to correctly expose the film, therefore, it is necessary to increase the amount of exposure, either by opening the diaphragm or by increasing the exposure time.

If you know the degree of magnification of the image in relation to the object, then you can use the following table that tells you how much to increase the exposure.

A simpler technique is to use the following formula because all you do is measure the length of the bellows with a ruler. The formula is:

$$\frac{\text{Bellows Length}^2}{\text{Focal Length}^2} = \text{Exposure Increase}$$

Here is how it works. Assume that your camera has a six-inch lens. After setting up the picture and getting the camera in focus, the measured distance between the center of the lens and the film plane is 11 inches. The equation is:

$$\frac{BL^2}{FL^2} = EI$$

$$\frac{11^2}{6^2} = EI$$

$$\frac{121}{36} = EI$$

$$3\frac{1}{3} = EI$$

This means that the exposure must be increased approximately 3⅓ times over what is called for by the light meter. A threefold increase means that you have to open up the lens by 1½ stops to get sufficient light to correctly expose the film. The ⅓ fraction can be disregarded because film has sufficient latitude so that small fractions of one stop can either be dropped or rounded off to the nearest number.

Code Notches for KODAK Sheet Films

Note: When the notch is at the right-hand side of the top of the sheet, the emulsion side faces you.

KODAK Black-and-White Films	Code Notch	KODAK Black-and-White Films	Code Notch
Commercial 4127 Commercial 6127		T-MAX 400 Professional 4053 (ESTAR Thick Base)	
Contrast Process Pan 4155 (ESTAR Thick Base)			
Contrast Process Ortho 4154 (ESTAR Thick Base)		Technical Pan 4415	
		TRI-X Ortho 4163 (ESTAR Thick Base)	
EKTAPAN 4162 (ESTAR Thick Base)		TRI-X Pan Professional 4164 (ESTAR Thick Base)	
Fine Grain Positive 7302			
High Speed Infrared 4143 (ESTAR Thick Base)		**KODAK Color Reversal Films**	**Code Notch**
KODALITH Ortho 2556, Type 3	No Notch	EKTACHROME 64 Professional 6117 (Daylight)	
KODALITH Pan 2568		EKTACHROME 100 Professional 6122 (Daylight)	
Matrix 4150 (ESTAR Thick Base)		EKTACHROME 100 PLUS Professional 6105 (Daylight)	
Pan Masking 4570		EKTACHROME 200 Professional 6176 (Daylight)	
Pan Matrix 4149 (ESTAR Thick Base)		EKTACHROME Professional 6118 (Tungsten)	
PLUS-X Pan Professional 4147 (ESTAR Thick Base)		EKTACHROME Duplicating 6121 (Process E-6)	
Professional Copy 4125 (ESTAR Thick Base)			
ROYAL Pan 4141 (ESTAR Thick Base)			
ROYAL-X Pan 4166 (ESTAR Thick Base)		**KODAK Color Negative Films**	**Code Notch**
Separation Negative 4131, Type 1		VERICOLOR III Professional 4106, Type S	
Separation Negative 4133, Type 2		VERICOLOR II Professional 4108, Type L	
SUPER-XX Pan 4142 (ESTAR Thick Base)		VERICOLOR Internegative 4112 (ESTAR Thick Base)	
T-MAX 100 Professional 4052 (ESTAR Thick Base)		VERICOLOR Internegative 4114, Type 2	
		VERICOLOR Print 4111 (ESTAR Thick Base)	

5 Setting Up

The following is the step-by-step process of setting up the camera, framing the subject, focusing the camera, and exposing the film.

1

Perspective. Position yourself so that the size relationships of the front and back parts of the subject give you the size relationships you will need in your completed photograph. This is the position where you should set up the camera.

2

Frame the subject. Center the image on the groundglass.

3

Focus the camera. You will find it useful that a view camera can be focused from either the front or the rear. By moving the back instead of the lens board, the lens-subject relationship remains constant and the image size on the groundglass remains the same. This is particularly useful when doing closeups where even a small movement of the lens can make a marked difference in subject size.

4

Check for coverage. With the camera positioned for the proper perspective, make certain that the lens covers enough of the subject from side to side and from top to bottom. And check to see if there is so much coverage that the needed part of the subject occupies only a small segment of the negative. If your framing is not what is needed, then change lenses for a focal length that will give you the proper coverage.

5

Refocus. If you changed to a different lens, then refocus.

6

Adjust image size. At this point, it generally will be necessary to make slight adjustments in image size. This calls for moving the camera either closer to or farther from the subject. If a major adjustment is needed, it will be necessary to move the entire tripod. For minor adjustments, it is possible to slip the camera rail backward or forward in its tripod mount. This moves the entire camera without the problems caused by repositioning the tripod.

7

Make corrections. If distortion is to be corrected, swing or tilt the camera back.

8

Recenter the image. Use the camera back slides or rises to recenter the image.

9

Adjust sharpness wedge. If depth is insufficient, swing the lens to position the main wedge of sharpness through the important points of the subject.

10

Additional sharpness adjustment. If distortion is no problem and it is not possible to swing the lens enough to precisely position the wedge of sharpness, the back may also be swung to aid in this positioning.

11

Reposition sharpness wedge. Refocus the camera back to more precisely position the wedge of sharpness.

12

Exposure increase. Calculate the exposure increase needed because of the bellows factor.

13

Check depth. Stop the diaphragm down while checking the groundglass to make certain there is sufficient depth of field.

14

Check picture area. If a compendium bellows is being used, check the four corners of the groundglass to be certain the bellows does not intrude into the picture area. Also check to make sure that nothing extraneous to the picture is visible on the groundglass. If it is, remove it.

15

Set shutter speed and cock. Close the shutter. Set the shutter speed appropriate to that which will give you the correct exposure based on the preselected diaphragm setting. Cock the shutter. Keep in mind that in situations where subject movement calls for a high shutter speed, either more light must be shone on the subject or a compromise must be made in the depth by using a larger diaphragm opening.

16

Insert holder. Pull back the spring-mounted groundglass and slide in either the cut-film or roll-film holder. Be certain all camera and tripod screws are firmly engaged or you might shift the focus when pulling out the spring back.

17

Remove slide. Check the lens to be certain it has been closed, then pull the dark slide from the holder.

18

Stop. Wait until any vibrations or movements of the camera have had a chance to subside.

19

Make the exposure. Always use a cable release to fire the shutter. Pressing the shutter-release button by hand could generate enough movement to dull the razor-edge sharpness possible with this type of camera.

20

Replace dark slide. More than one piece of film has been ruined because the holder was pulled out of the camera before the dark slide was replaced.

21

Lock it. Turn the latches on the end of the holder to make certain it is not accidentally pulled out.

22

Check slide. In replacing the slide, be certain it has been turned so that the *black side is facing out*. This indicates that the film has been exposed. It is easy to become confused and make a second picture on the same piece of film if this procedure is neglected.

23

Advance film. When using a roll-film holder, *advance the film immediately* after the exposure has been made so there is no danger of making a second exposure on top of the first one.

24

Check focus. Remove the holder, open the camera shutter and diaphragm, and recheck the focus to make certain it didn't shift while you were manipulating the camera.

6 The Camera Movements

Chapter Contents

In approaching the use of the view camera, it is important to realize that there are only four basic individual movements.

1. The lens can be pivoted around its optical center.
2. The lens can be moved from side to side or up or down in relation to the film.
3. The groundglass can be pivoted.
4. The groundglass can be moved from side to side or up and down.

These movements are not necessarily just vertical or horizontal, but can be any place in between as well. This means that the lens, film, and subject relationship have an infinite number of potential positions. However, if the primary movements and what they accomplish are understood, then mastery of the view camera is well within your reach.

Keep one basic rule in mind at all times: In order to have control over what you are doing, it is necessary to have a starting place from which you can work. This starting place is the neutral, or zero, position. That is, all swings, tilts, and slides are centered and in the neutral, or zero, position. The shutter should be open and the diaphragm at its widest opening.

Another thing to be aware of is that for every correction you make, it will be necessary to make either focusing or positioning adjustments. In other words, every time you swing or tilt either the back or the lens, you will have to refocus or slide either the lens or back from one side to the other, or raise or lower one or the other to recenter the image.

The reason for this is that any time there is a manipulation of either the swings or tilts, there will be a change in the relationship between the groundglass and the optical center of the lens. These changes will be greater with cameras having bottom swings than with those with swings located at the center of the lens board and back, but changes will nevertheless occur with both types of camera.

Keep in mind that the image on the groundglass is upside down and backward. This is perhaps one of the most difficult aspects of working with the view camera. But as stated earlier, you can get around this problem by using a reflex viewing back, which can be mounted on the camera in place of the normal groundglass. Many cameras now have such an accessory.

DEFINITIONS

Rise

When either the camera lens board or back is raised vertically from the centered, or neutral, position.

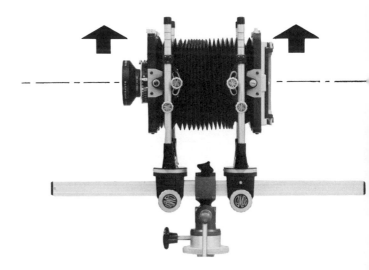

Fall

When either the camera lens board or back is lowered vertically from the centered, or neutral, position.

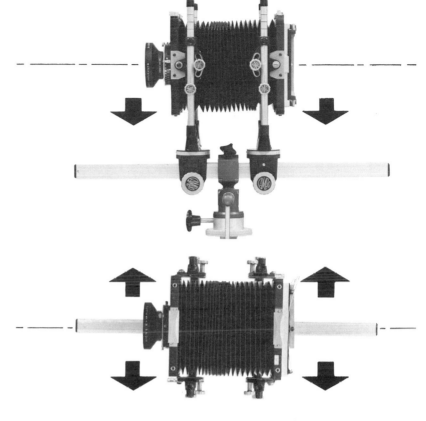

Slide

When either the camera lens board or back is moved horizontally from the centered, or neutral, position.

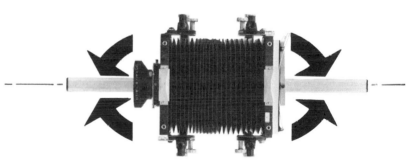

Swing

When either the camera lens or back is rotated around its vertical axis. Swinging the back of the camera is discussed in terms of the film *emulsion*.

Tilt

When either the camera lens board or back is rotated around its horizontal axis.

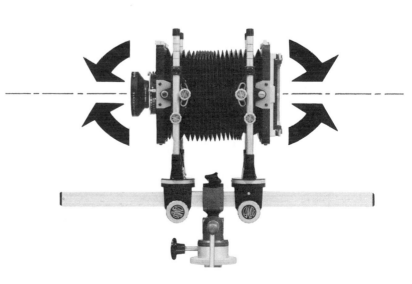

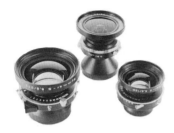

LENS
Slides
Rises and Falls

Moving the lens either up or down or from side to side changes the relationships between objects that are close to the camera and those which are farther away. In addition, moving the lens shifts the position of the image in the picture.

The reason is simple. The lens is that part of the camera which *sees* the subject. When it is moved from side to side or up or down, its relationship with the various parts of the subject changes. If it moves to one side of the subject, more of that side can be seen. Moreover, anything behind the front part of the subject will also have shifted in its relationship to the rest of the subject.

You don't need a camera to observe this. Just look at any two objects, one behind the other. Now cover one eye. If you move your head to one side, the foreground object will have moved in the opposite direction in relation to the rear object.

One other aspect of this phenomenon of apparent movement is to observe three objects more or less in line with each other. If you move your head to one side, both the front and center objects will have moved in the opposite direction in their relationship to the rear object. In addition, the foreground object will have moved a great deal more than the center one.

The Setup

In the accompanying illustrations, remember that what you are seeing is not the way the image appears on the groundglass, but rather the final result of the camera movements as they affect the final print.

The camera lens, the ball, and the blocks are all centered so that the image on the groundglass is of the ball centered on the block. The image of the ball and the block is centered on the groundglass. All camera positions are in neutral.

LENS NEUTRAL, IMAGE CENTERED, BALL CENTERED.

This is the neutral position as seen from the top. Note how the ball is centered on the block, side to side and top to bottom. In addition, the image is in the center of the picture.

LENS MOVES LEFT, IMAGE MOVES RIGHT, BALL MOVES RIGHT (IN FINAL PRINT).

The camera lens is slid to the left, as in this illustration. The result is that the entire image shifts to the right. Of greater importance, however, is that the image of the ball has moved to the right in the relationship between the ball and the block. Notice that the ball no longer touches the 0 or the 2 in the block, but now very much obscures the R and the S. More obvious is that the post supporting the ball has moved to the right of the block's centerline.

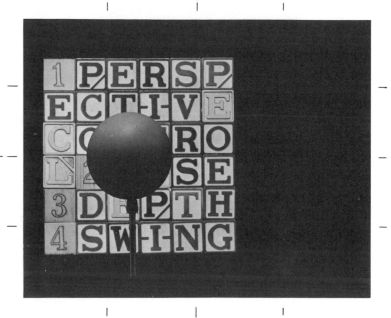

LENS MOVES RIGHT, IMAGE MOVES LEFT, BALL MOVES LEFT (IN FINAL PRINT).

The camera lens is slid to the right. The result is that the image shifts to the left, with the ball moving left in relationship to the block. The 0 and 2 are almost covered while the R and S are completely visible. And now the post supporting the ball is to the left of the block's centerline.

LENS NEUTRAL, IMAGE CENTERED, BALL CENTERED.

This is the neutral position as seen from the side, in which everything is centered.

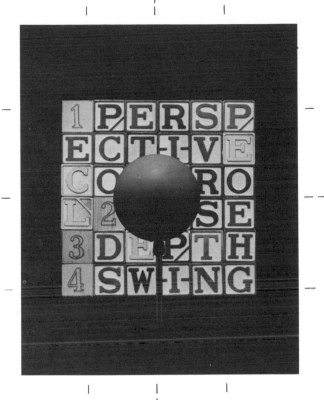

LENS RISES, IMAGE DROPS, BALL DROPS (IN FINAL PRINT).

The camera lens is raised above the centerline. The result is that the image now moves down on the picture and the ball drops down in relationship to the block. The T and I are completely visible while the E and P are almost obscured.

LENS FALLS, IMAGE RISES, BALL RISES (IN FINAL PRINT).

The lens is lowered below the camera's centerline. The result is that the image now moves up in the picture and the ball moves up in relationship to the block. Note that the T and I are covered while the E and P are visible.

Review

LENS SLIDES, RISES, AND FALLS

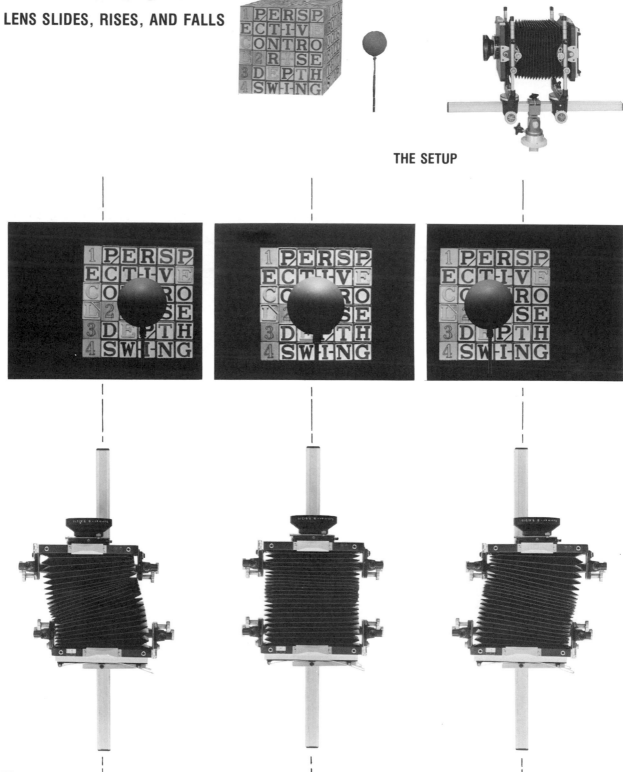

THE SETUP

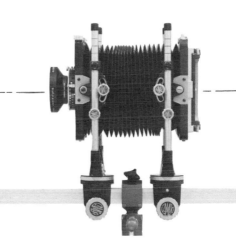

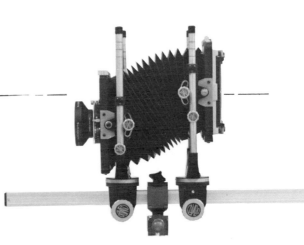

BACK

Slides
Rises and Falls

Moving the camera back vertically or horizontally will shift the image position on the film without changing the camera's point of view in relation to the subject.

What happens here is that the image itself is not actually being moved. It remains stationary while the film is being shifted so that the image falls on different sections of it. Where the image falls depends on the direction in which the film shifts. This is the primary control for centering the image on the groundglass after the picture has been set up.

The Setup

The camera lens, the ball, and the blocks are all centered so that the image on the groundglass is of the ball centered on the block. The image of the ball and the block is centered on the groundglass. All camera positions are in neutral.

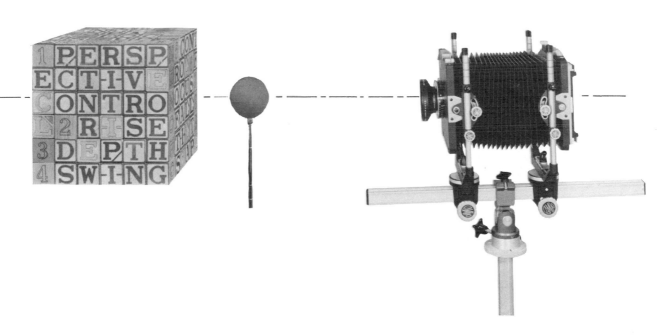

BACK CENTERED, IMAGE CENTERED.

This is the neutral position as seen from the top. The lens, ball, and block are all centered on a single line, and the resulting image is centered on the film.

BACK SLIDES LEFT, IMAGE MOVES LEFT (IN FINAL PRINT).

The camera back is slid to the left. The result is that the entire image moves left on the print without changing the relationship between the ball and the block.

BACK SLIDES RIGHT, IMAGE MOVES RIGHT (IN FINAL PRINT).

The camera back is slid to the right. The ball still remains centered on the block, however the image moves to the right, as shown in the illustration.

BACK CENTERED, IMAGE CENTERED.

This is the neutral position as seen from the side. Here, too, the lens, ball, and block are all centered on a single line, and the resulting image is centered on the film.

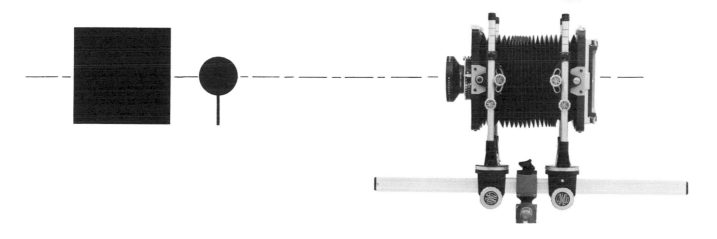

BACK RISES UP, IMAGE MOVES UP (IN FINAL PRINT).

The camera back is raised. The result is that the image of the ball and block move up in the picture. There is still no change in the relationship of the ball and block.

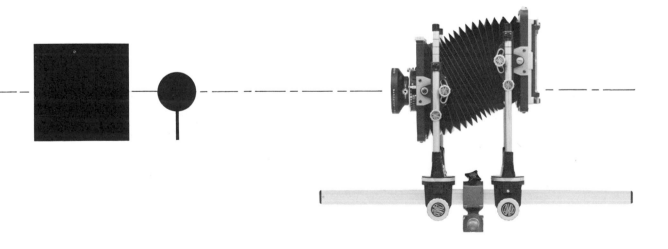

BACK MOVES DOWN, IMAGE MOVES DOWN (IN FINAL PRINT).

The camera back is lowered below the lens centerline. The result is that the image moves downward in the illustration. Again, there is no change in the relationship of the ball and the block.

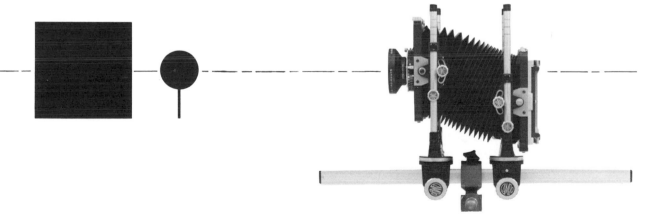

Review

BACK SLIDES, RISES, AND FALLS

 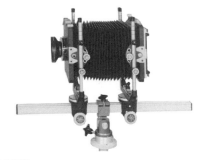

THE SET UP

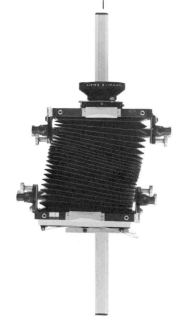

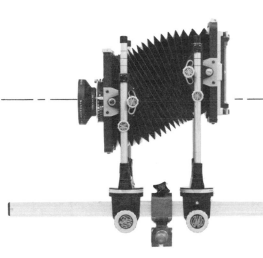

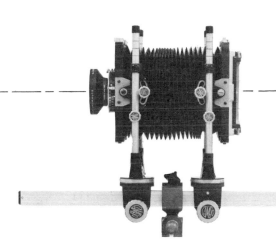

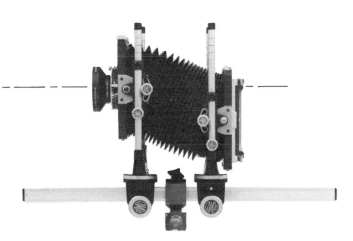

LENS
Swings and Tilts

Rotating the camera lens, that is, swinging or tilting it around its optical center, will change the plane of sharp focus without distorting or changing the shape of the object or changing its position on the film. When a lens is focused on a particular subject, everything in the same plane as that subject is also in focus as long as the lens and film plane are parallel. This plane of sharp focus is parallel to the lens board and perpendicular to its axis. Consequently, when the lens is rotated around its optical center, this plane of sharp focus rotates also, although it no longer remains parallel to the lens plane. What now comes into play is known as the Scheimpflug effect. This theory states that if the plane of the film, the plane of the lens, and the plane of the subject all meet at a common point, a picture of the subject will be sharp from near edge to far, and everything lying on the plane of the subject will be in sharp focus.

Let's put two objects down on the floor in front of the camera with a considerable distance between them. Then, we tip the camera downward so both objects show on the groundglass. Now, if we focus on the near object, the distant one will be out of focus; on the far object, the near one will be unsharp.

With cameras having fixed lenses, the only way to try to get both objects in focus is to first focus on a point approximately one-third of the distance between them, and then stop the lens down as far as possible to make the picture with a very small aperture. Hopefully, the depth of field will make both objects reasonably sharp. We can cheat a bit by focusing in favor of the near object, because if part of a distant subject is slightly unsharp, it is not as noticeable as when part of a nearby subject is out of focus. It is highly unlikely, if the objects are quite far apart, that we will get both of them in sharp focus.

With a view camera, by taking advantage of the Scheimpflug effect, we can greatly increase depth of field (see diagram below). By tilting the lens downward so that the plane of the lens, the plane of the film, and the plane of the floor all meet at a common point, everything lying on the plane of the floor will be in sharp focus—even with the lens wide open. By stopping down, we can get depth of field above the floor and underneath it. This is especially useful if the surface you're photographing is transparent or if part of the subject extends down beneath it.

Keep in mind that the Scheimpflug effect has to do with the lens, the film, and the subject, regardless of where the subject plane happens to be. In other words, if you want to get two points on a wall in sharp focus, the lens would be swung to the side. If the subject is on the ceiling, the lens would be tilted upward.

The Scheimpflug Effect

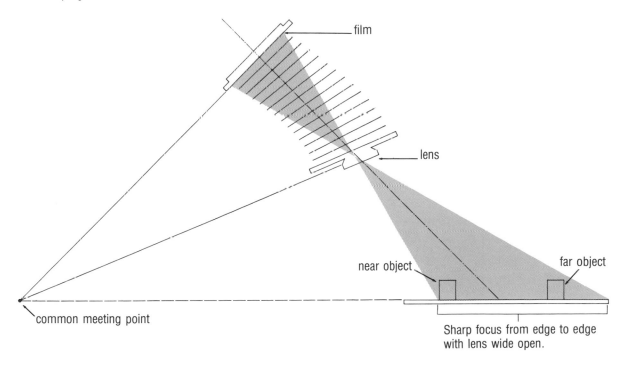

film

lens

near object

far object

common meeting point

Sharp focus from edge to edge with lens wide open.

The Setup

The cube of building blocks is set up at a 45-degree angle to and centered on the camera lens so that the image is centered on the film.

LENS NEUTRAL, DEPTH OF FIELD SHALLOW.

This is the neutral camera position as seen from the top. The point of focus is on the front edge of the cube, hence both rear corners of the cube are out of focus.

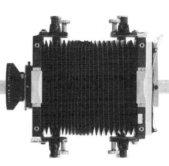

LENS SWINGS LEFT, RIGHT FACE OF IMAGE (IN FINAL PRINT) IS SHARP.

The camera lens is swung toward the left so that the plane of the right face of the cube, the lens plane, and the film plane meet at a common point. That face is now sharp from front to rear. However, the left edge of the left face becomes less sharp than before.

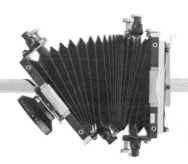

70

LENS SWINGS RIGHT, LEFT FACE OF IMAGE (IN FINAL PRINT) IS SHARP.

The camera lens swung to the right so that the plane of its front surface, the plane of the cube's left face, and the film plane all meet at a common point. That face is now sharp from front to rear while the other face becomes unsharp.

 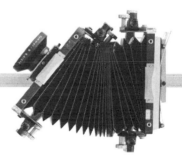

The
Setup

The cube of building blocks is set up at a 45-degree angle to and centered on the camera lens so that the image is centered on the film.

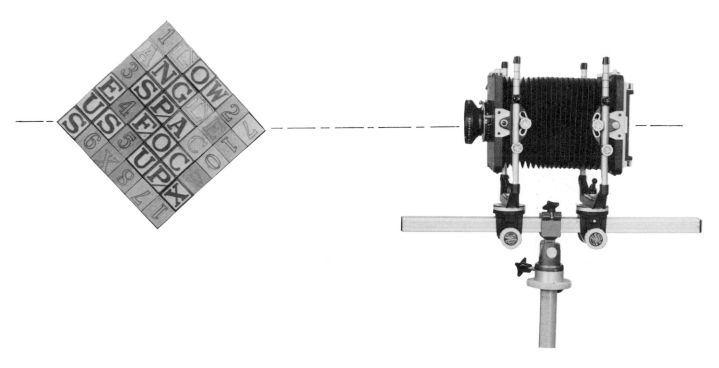

CAMERA NEUTRAL, DEPTH OF FIELD SHALLOW.

This is the neutral camera position as seen from the side. Again, focus is at the front corner of the cube, hence the back of the cube is unsharp.

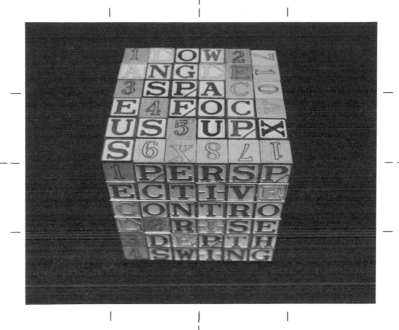

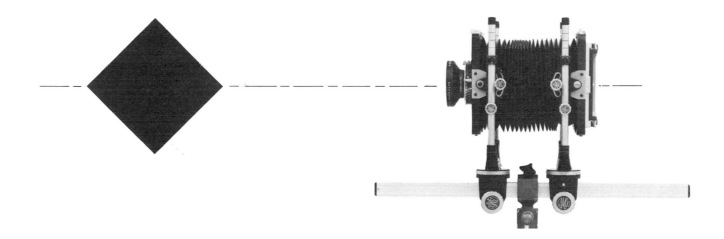

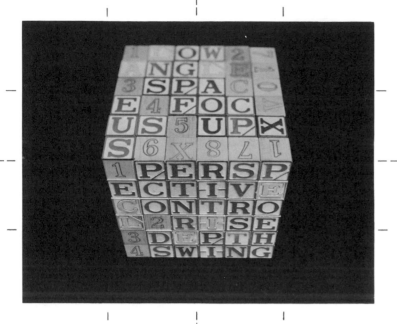

LENS TILTS UP, BOTTOM SURFACE OF IMAGE (IN FINAL PRINT) IS SHARP.

The lens is tilted upward so that its plane, the plane of the cube's bottom surface, and the film plane meet at a common point. That surface now comes into sharp focus from front to rear while the top becomes less sharp.

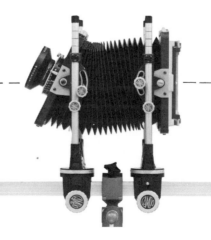

LENS TILTS DOWN, TOP SURFACE OF IMAGE (IN FINAL PRINT) IS SHARP.

The lens is tilted downward so that its front surface, the plane of the top of the cube, and the film plane meet at a common point. Consequently, the top is sharp while the bottom becomes more and more unsharp.

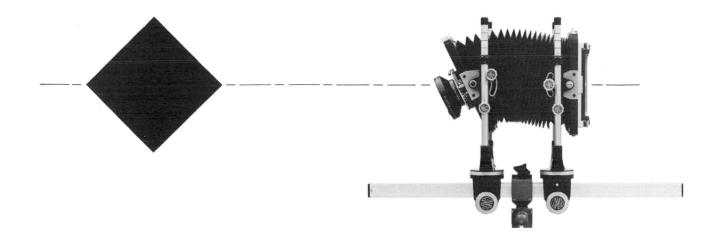

Review

LENS SWINGS AND TILTS

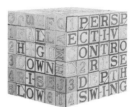

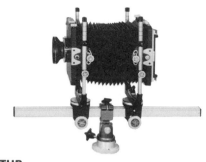

THE SETUP

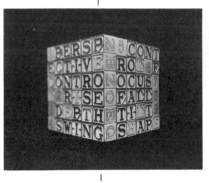

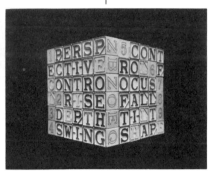

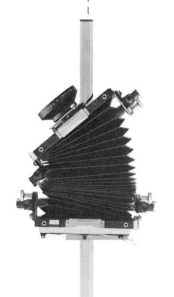

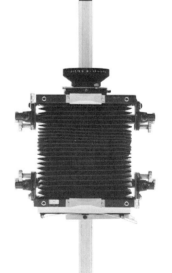

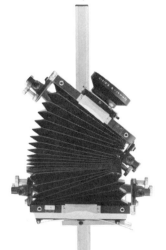

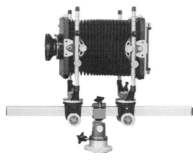

THE SETUP

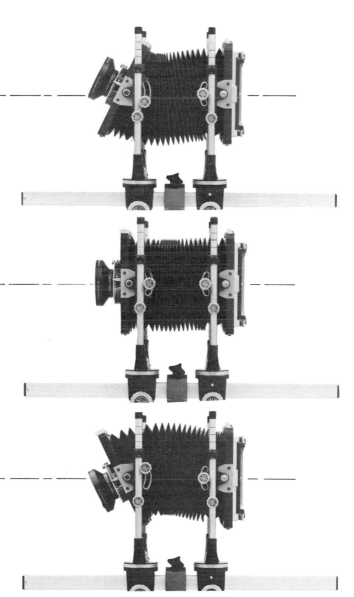

BACK

Swings and Tilts

Pivoting the camera back changes the shape of the subject by elongating it. The elongation is horizontal when the back is swung and vertical when it is tilted. Keep in mind that the farther the groundglass is from the lens, the larger the image will be. As a consequence, when the groundglass is pivoted, the center of the image remains the same size, the part of the groundglass that moves away from the lens will become larger, while the part on the groundglass that moves closer to the lens will become smaller. In effect, if the subject is square, it will become trapezoid in shape.

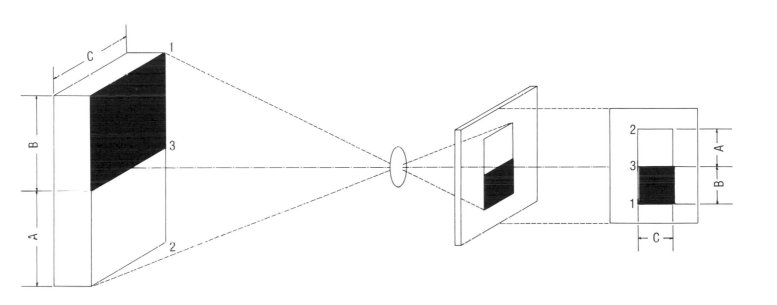

In the diagram on this page, you will note that parts A and B of the subject are exactly the same size. When projected onto the film plane, which is parallel to the subject plane, they still remain equal.

Now let us examine the diagram below. Here the rear of the camera has been tilted upward. Keep in mind that the tilt takes place on the central axis, so the center of the film plane remains exactly the same distance from the lens as it was before the film plane was tilted. Let's look at edge 1′ on the subject and the place where it falls on the film plane. Because the film plane has been tilted, the part where the 1′ intersects it is much closer to the lens than the centerline 3′. Because it is closer to the lens, it is smaller than it was before. Therefore, segment B′ has been compressed, making it smaller than it was before. Conversely, because edge 2′ falls on the film plane considerably farther away from the lens, it has space to spread out. It intersects the film plane at a greater distance from the centerline. The segment from the centerline to edge 2′ has become considerably larger.

If we examine the image as it appears on the film, the image will appear to have shifted its position on the film, in effect moving toward the side where the image has become larger. In reality, however, this has not happened. The center portion of the image (3′) has remained exactly in the center of the film, and it hasn't changed its size. What has happened is that edge 1′ falls on the film plane closer to the centerline than before, and edge 2′ falls on the film plane farther away from centerline 3′, creating the visual impression that the image has shifted its position on the film.

If desired, this off-center appearance can be corrected without affecting the image by raising the back to recenter the total image.

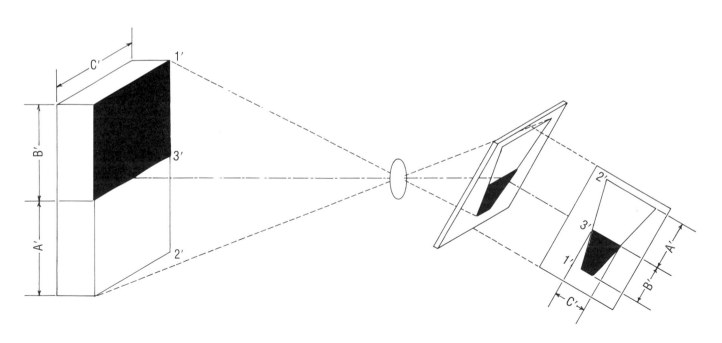

The Setup

The camera is centered vertically and horizontally with the front surface of the block. The image is centered on the groundglass, and the block, lens, and film are all in parallel planes.

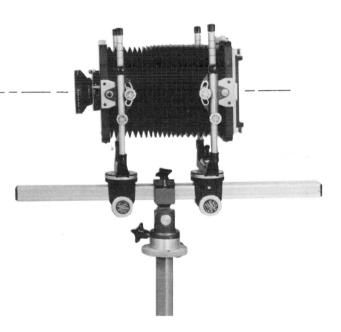

CAMERA NEUTRAL, IMAGE IS SQUARE.

With the camera in the neutral position, the back, lens, and block surface are parallel and the image has the same dimension on all sides.

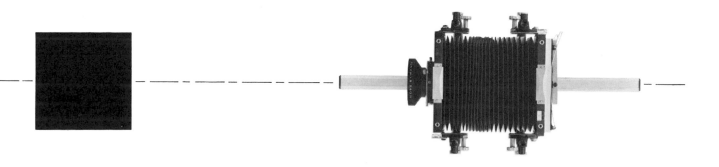

RIGHT SIDE OF BACK SWINGS AWAY FROM LENS, LEFT SIDE OF IMAGE (IN FINAL PRINT) GETS BIGGER.

The right side of the back is moved away from the lens, which makes the left side of the image larger in the final print. Note that the vertical lines remain parallel although their spacing has become narrower on right side of the picture and greater on the left side. The block's centerline still remains in the center of the picture.

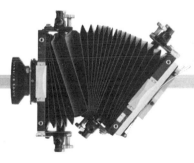

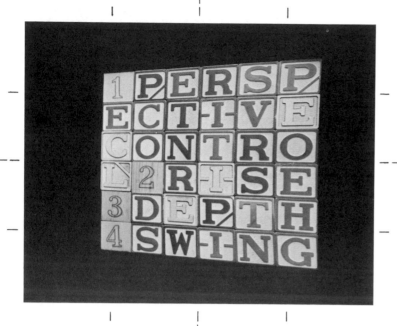

LEFT SIDE OF BACK SWINGS AWAY FROM LENS, RIGHT SIDE OF IMAGE (IN FINAL PRINT) GETS BIGGER.

Moving the left side of the camera back away from the lens makes the right side of the block bigger. The left side of the block becomes smaller as the right side of the film gets closer to the lens. The size of the middle area remains the same.

BACK NEUTRAL, IMAGE SQUARE.

The neutral position as seen from the side. The image of the block is square.

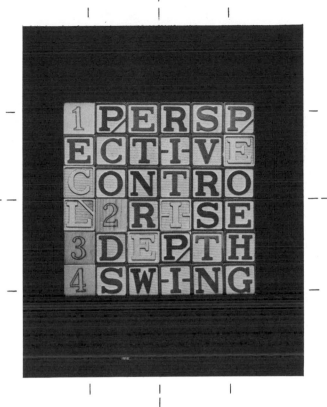

BACK TILTS UP, BOTTOM OF IMAGE (IN FINAL PRINT) BECOMES LARGER.

The camera back is tilted upward, which moves the bottom of the back closer to the lens. The result in the final print is that the block moves downward and the bottom becomes larger.

BACK TILTS DOWN, TOP OF IMAGE (IN FINAL PRINT) BECOMES LARGER.

The camera back is tilted down, which moves the bottom farther from the lens. The result is that the block moves upward and the top becomes larger.

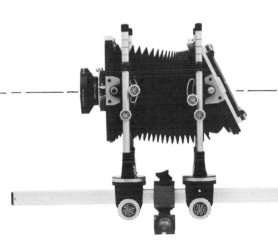

87

Review

BACK SWINGS AND TILTS

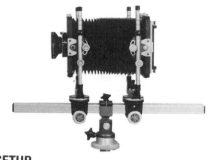

THE SETUP

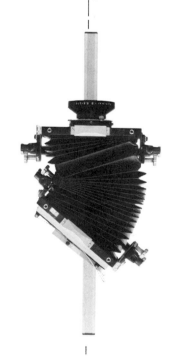

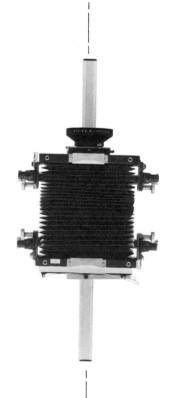

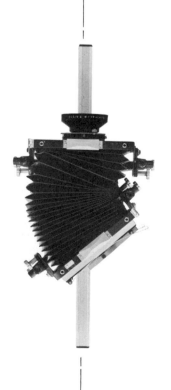

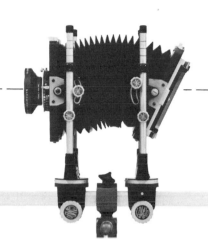

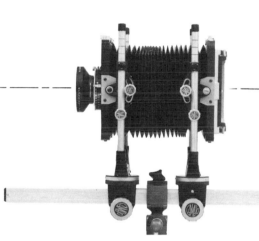

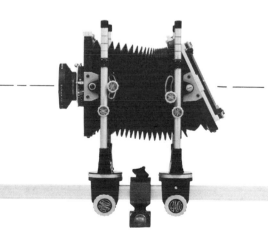

89

7 Controlling the Image

Chapter Contents

Linear
Convergence

It is possible to control the degree to which lines converge or diverge by swinging or tilting the camera back. As the back pivots around its center, one side gets farther from the lens and the other gets closer. Remember, the farther the groundglass is from the lens, the larger the image will be. Therefore, on that part of the back which has moved away from the lens, the image becomes larger. Conversely, on that part of the back which has swung closer to the lens, the image becomes smaller. At the exact center where the lens-to-groundglass distance did not change, the image remains the same size.

Controlling the shape of the image, however, can only be carried out in one plane at a time. And as you make changes in the camera settings to control the lines in one plane of the picture, you increase the distortion in other planes. Therefore, it is important to decide beforehand which area is of greatest importance and which ones can stand the most distortion. (Consult the section on back swings and tilts for more details on linear convergence.)

The Setup

The cube of building blocks is set up at a 45-degree angle to and centered on the camera lens so that the image is centered on the film. The ball is set up at the right edge of and centered on the large cube.

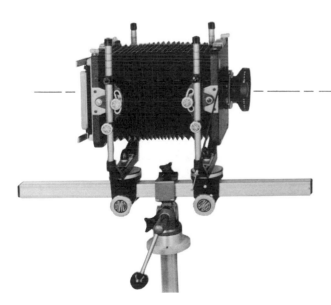

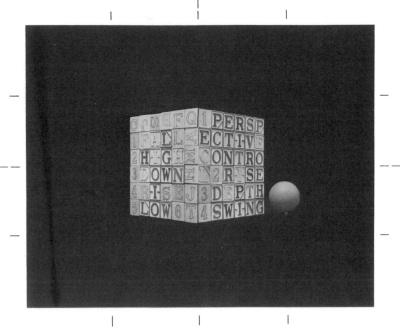

CAMERA SETTINGS NEUTRAL, IMAGE NEUTRAL.

With the image centered, the tallest segment is the front corner of the block. Both sides are symmetrical and the ball is round.

94

BACK SWINGS TO RIGHT, LEFT SIDE OF IMAGE (IN FINAL PRINT) BECOMES SQUARE.

Swinging the camera back to the right causes the converging lines on the left side of the picture to spread out, thereby squaring up that segment of the image. In addition, the horizontal lines become elongated so that the left side of the block is considerably wider than it was in the neutral camera position. On the right side, however, the horizontal lines now converge even more than they did before, resulting in the height of the right side being reduced by approximately 20 per cent. The image of the ball has also become smaller and has flattened into a slight horizontal oval.

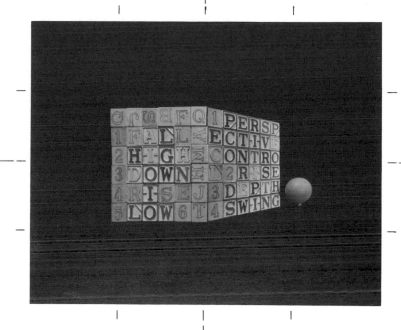

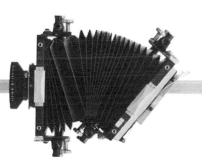

BACK SWINGS TO LEFT, RIGHT SIDE OF IMAGE (IN FINAL PRINT) BECOMES SQUARE.

Swinging the back to the left reverses the effect created in the illustration on page 95. However, note what has happened to the ball. It has become 50 per cent higher than it was and more than twice as wide as it was in the neutral camera position. This is considerably more change than occurred in the block which only widened by 50 per cent. Its rear edge got only about 20 per cent higher. The point is, that the closer you come to the edge of the picture, the greater the amount of change that will take place as the camera back is swung.

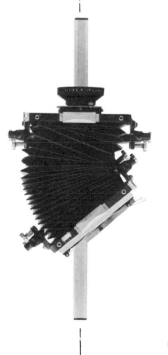

Review

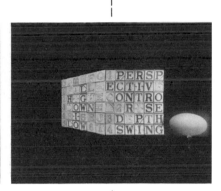

THE SETUP

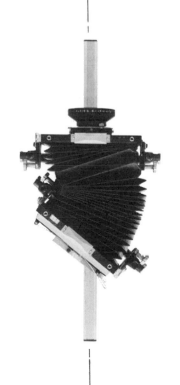

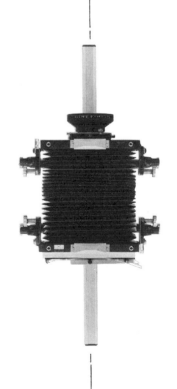

Shape Control

Control of the shape of the image is achieved by movement of the camera back. A broad range of control is possible by combining swings (horizontal) or tilts (vertical) with rise and fall or side-to-side movements of the camera back.

Swings and tilts may be used simultaneously. When either or both are used, the image is displaced on the groundglass and it is necessary to slide the back from one side to the other, raise or lower it, or use a combination of these in order to re-center the image. Always remember that when you move the camera back to correct distortion in one plane, you will be introducing distortion into another plane. Therefore, it is important to be aware of what is happening so that the introduced distortion does not spoil your picture.

One optical fact of life is that circular objects will become less circular the farther they are from the center of the groundglass. Additionally, their horizontal and vertical axes will incline away from the vertical or horizontal the nearer these objects come to the corners of the photograph. This effect is particularly noticeable when using wide-angle lenses, but is present to some extent with all lenses. However, the longer the lens focal length used, the less of this sort of distortion introduced into the photograph.

The following pictures show how shape can be manipulated to achieve whatever end effect you desire, and how it can be corrected when it is distorted. Basically, we have created a simple setup of a box and an orange in a plate so that we have three basic shapes: the oval, the rectangle, and the sphere.

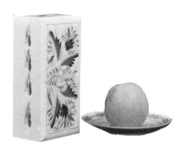

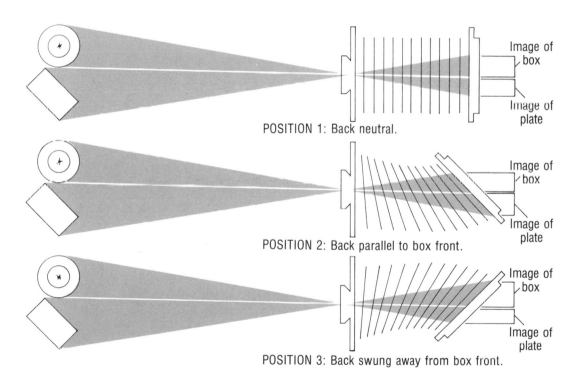

POSITION 1: Back neutral.

POSITION 2: Back parallel to box front.

POSITION 3: Back swung away from box front.

For each of four series an exposure was made at each of these three positions. We created the 12 combinations of positions into which it is possible to swing and tilt the back. Each position changed the shape of the image, sometimes in one plane and sometimes in another.

The Setup

FIRST SERIES

The camera was set up in a neutral position, although angled to the subject, and an exposure was made. Then the back was swung left and another exposure was made. Finally, the back was swung right and a third exposure was made.

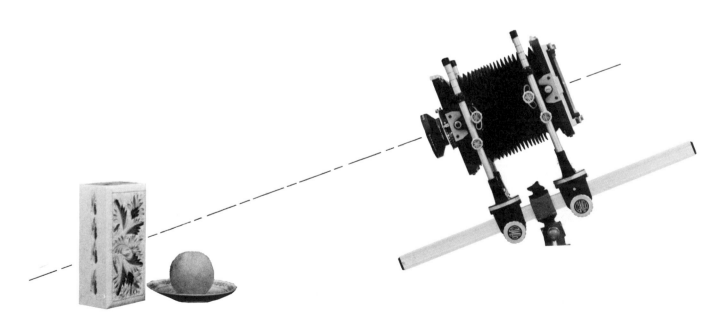

FIRST SERIES, POSITION 1

All camera positions are in neutral. The camera is above and tilted down approximately 20 degrees. It is also to the side and angled approximately 20 degrees to the front of the box. In this position, the top of the box is slightly larger than the bottom. Notice that the central vertical axis of the picture passes through the right edge of the box. Because the swings are through the camera's optical center, this edge of the box always remains in the center of the picture and is the same length in the two other pictures in this set.

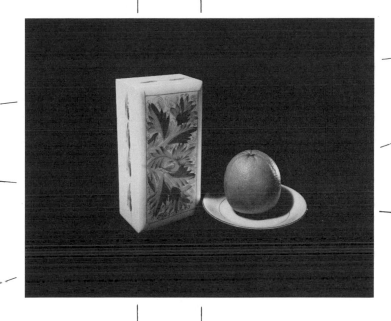

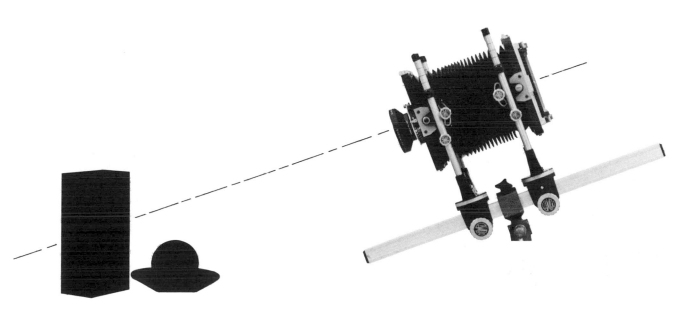

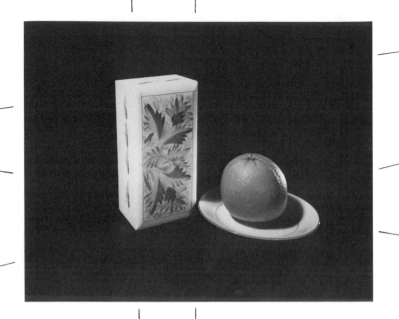

FIRST SERIES, POSITION 2

The camera back is swung so that it is parallel with the front of the box. This means that the right side of the film is closer to the camera lens than before, and the left side is farther away. The result is that the left side of the box has gotten shorter, bringing the top and bottom of that side closer together and thereby making the top and bottom edges more parallel. At the same time, because the left side of the film plane is farther away from the orange, the orange becomes broader and taller. Also, the angle of the axis of the plate with the vertical edge of the box becomes greater. This results in the elongation along the plate axis, which gives it an egg-shaped appearance.

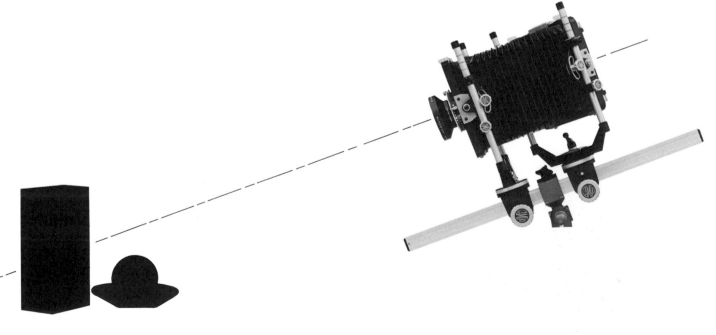

102

FIRST SERIES, POSITION 3

The camera back is swung away from the front of the box (see diagram below). The result is that the right side of the camera back has moved farther away from the box, and the left side of the back has moved closer to the orange on the plate. Consequently, the image of the box has stretched more to the right side of the camera back and this right side has become longer because it is farther away from the lens. Remember, the farther the film plane from the lens, the larger the image. The angle that the base of the box makes with the right side is more acute, and the central axis of the plate has swung around more to the horizontal, giving a more horizontal oval shape. The orange has also become slightly smaller because this part of the film plane is closer to the lens than before.

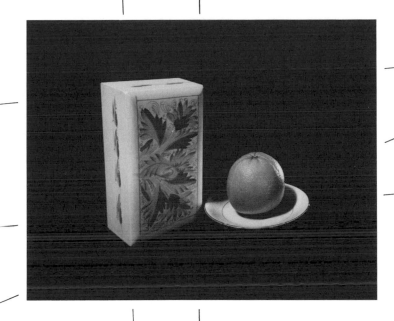

The Setup

SECOND SERIES

The camera was set up and the back tilted until it was vertical. Again, a series of exposures at neutral, left, and right was made.

SECOND SERIES, POSITION 1

The camera and subject are set up in Position No. 1. The camera back is then tilted backward until it is vertical, making it parallel vertically with the front surface of the box. The result is that the left and right edges of the box are parallel to each other instead of converging toward the bottom as they do in Set No. 1. Note how the main axis of the plate has shifted around till it is almost horizontal.

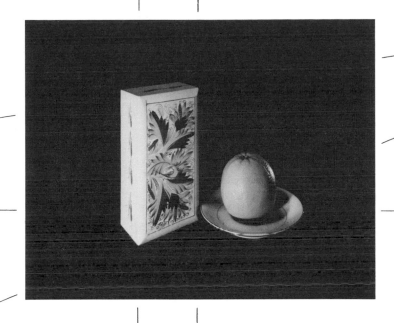

SECOND SERIES, POSITION 2

The camera back is swung so it is parallel with the front of the box (see below). The result is that the top and bottom of the box are now more nearly parallel, causing the box to become more square. What has happened is that the left edge of the box has become shorter while the right edge has remained the same length. However, the right side of the picture, occupied by the right edge of the plate and the orange, has become longer because the left side of the camera back is farther from the lens. As a result, the axis of the plate shifts excessively away from the almost horizontal position it had assumed in Position No. 1. In addition, the orange has elongated and broadened along the axis of the plate to assume the shape of an egg.

SECOND SERIES, POSITION 3

With the camera back still in the vertical position, it is now swung away from the front of the box. Now the left side of the box becomes elongated, although the left and right sides still remain parallel. A secondary result is that the box has also broadened to the left. The right side of the box remains unchanged because it lies on the center axis of the film. The axis of the plate shifts dramatically because the right side of the plate and orange are now much closer to the left side of the film. Note how the orange has flattened out until it is almost as broad as it is high.

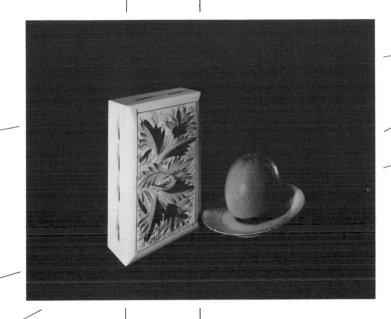

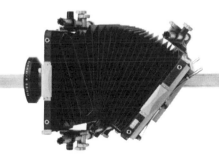

The Setup

THIRD SERIES

The camera was set up and the back tilted even farther
back than the vertical, and again our three exposures
at neutral, left, and right were made.

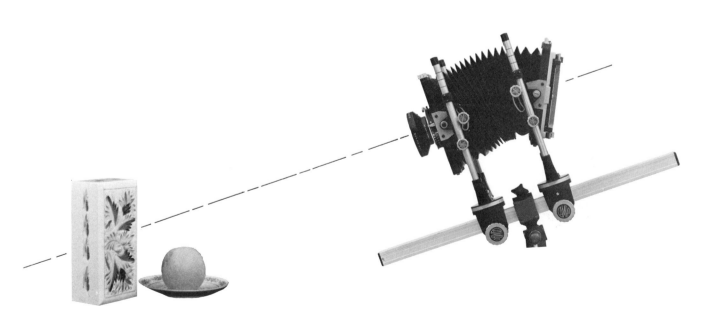

THIRD SERIES, POSITION 1

The camera and subject are set up as in Position No. 1, Set No. 1. Then the camera back is tilted backward, past the vertical, so that the top of the camera back is farther away from the box than the bottom. The result is that the top of the box becomes narrower and the bottom becomes broader. The same is true for the plate and the orange but to a lesser degree, because their top and bottom are not so far removed from the horizontal central axis of the picture. There has been also a considerable top and bottom elongation of both the box and the orange.

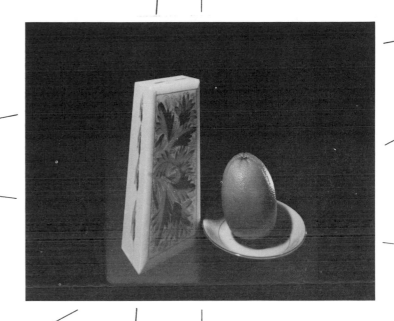

109

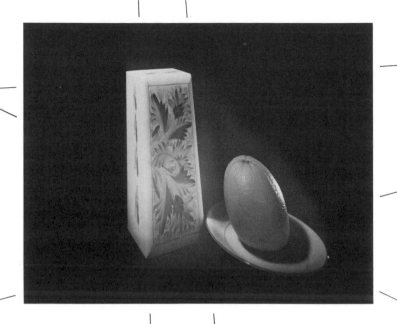

THIRD SERIES, POSITION 2

The camera back is swung so that it is parallel with the front of the box. The result is a squaring up of the box because as the right side of the back comes closer to the lens, there is a marked shortening of the left side of the box. In moving the left side of the camera away from the lens, the result is excessive elongation of the elliptical shape of the plate and the egg shape of the orange. This also results in a broadening of the image from side to side, especially in terms of the width of the plate. Note how the right side of the box, which is the central axis of the picture, has been tipped to the left.

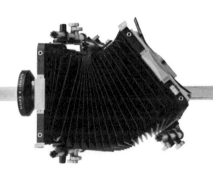

THIRD SERIES, POSITION 3

The back is swung away from the front surface of the box, with a subsequent elongation of the left side of the picture and a shortening of the right side. This again results in a narrowing of the plate and orange and a broadening of the box away from its right edge, which is the central axis of the picture. Again, the axis of the plate shifts dramatically and the orange assumes a more nearly vertical position although it is still elongated because of the excessive back tilt of the camera back. Note how the central vertical axis has been tipped to the right.

111

The Setup

FOURTH SERIES
We reversed ourselves and tilted the camera back forward from the neutral position; again, three exposures—center, left, and right—were made.

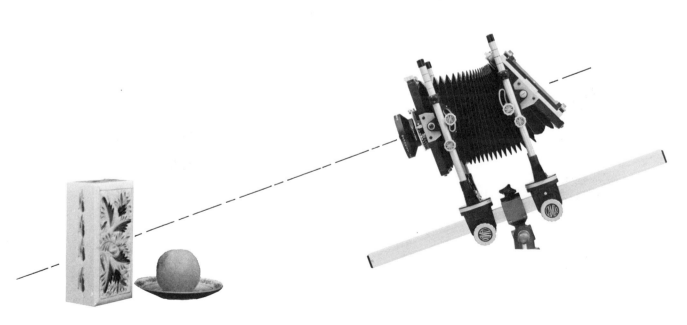

FOURTH SERIES, POSITION 1

The camera is set up as in Position No. 1, Set No. 1. The camera back is then tilted forward, making its plane even farther away from the vertical. The result is that the bottom of the film plane is even farther away from the bottom of the box than it was in Position No. 1, Set No. 1. Consequently, there is an exaggerated enlargement of the top of the box and a slight narrowing of the bottom of the box. The upper left side of the box therefore tips out at an extreme angle, making it even less parallel to the vertical right side. Moreover, the orange assumes an almost round shape and the plate axis is almost horizontal.

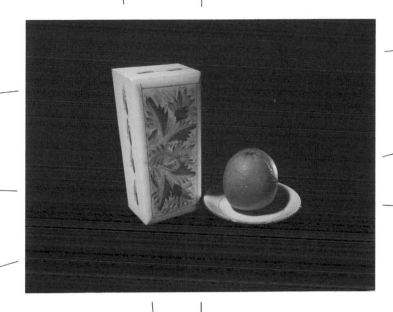

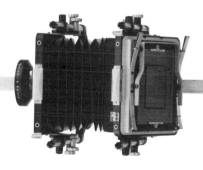

FOURTH SERIES, POSITION 2

The camera back is swung parallel with the front of the box. The most obvious change is the way the top of the box shifts to the right, causing the vertical right side to tip at an extreme angle to the right. In addition, the axis of the plate shifts and the orange looks as though it is about to roll off to the right; in all the other shots, it appeared to tip over to the left.

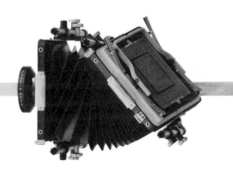

FOURTH SERIES, POSITION 3

The camera back is swung away from the front of the box. Again, the most obvious shift is in the way the top of the box has moved. This time, it is excessively to the left, exactly opposite to the shift resulting from camera Position No. 2. It is the tipping of the central or right edge of the box away from the vertical that has caused the shift of the top of the box. Note how the plate and orange axis have shifted so it now appears that the orange will roll off the plate to the left.

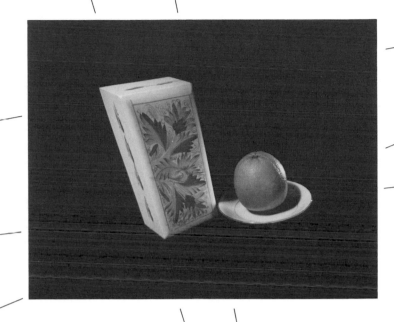

Review

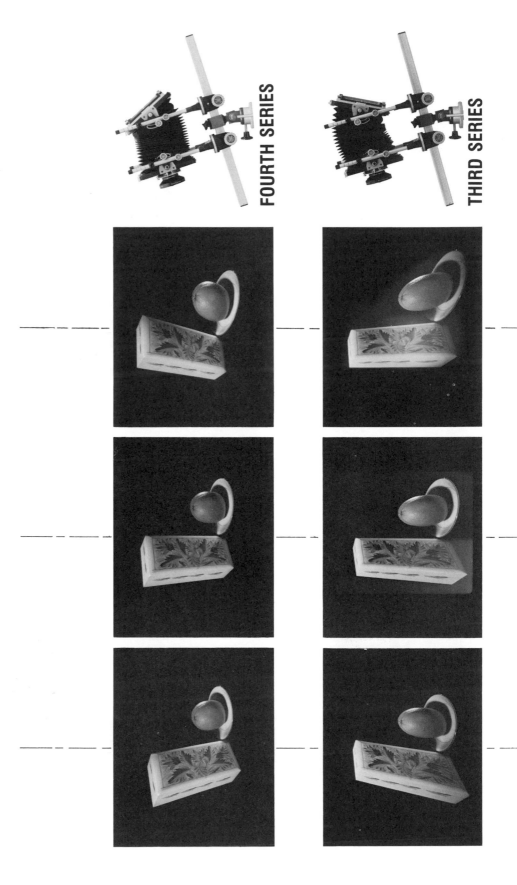

FOURTH SERIES

THIRD SERIES

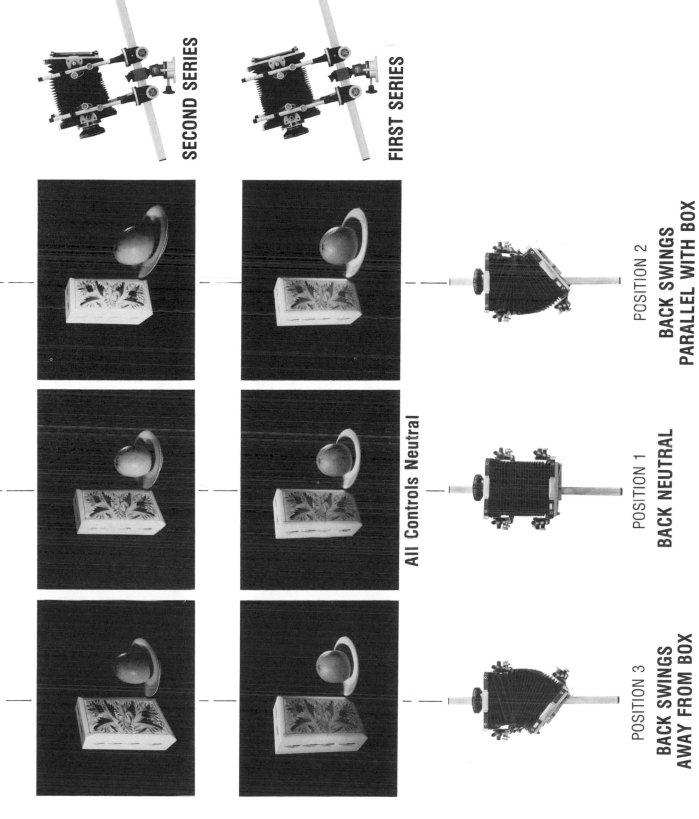

SECOND SERIES

FIRST SERIES

All Controls Neutral

POSITION 2
BACK SWINGS
PARALLEL WITH BOX

POSITION 1
BACK NEUTRAL

POSITION 3
BACK SWINGS
AWAY FROM BOX

117

Depth
Control

Control of the area of sharpness, or depth of field, is primarily the function of the swings and tilts of the front of the camera, although the area of sharpness can be controlled by the camera back.

The lens is used to control this area of sharpness because it introduces little distortion into the shape of the subject. Using the camera back will usually alter this shape dramatically, thereby distorting it. Traditionally, the camera back is used to control the subject shape while the lens is used to control the area of sharpness.

1. Aperture size. At its fullest aperture, depth is extremely shallow. When stopped down to its smallest opening, a considerable area both in front of and behind the plane of focus will be sharp. Generally speaking, the depth of the area of sharp focus will be approximately twice as great behind the plane of focus as in front of it.

2. For any given aperture, the farther the lens is from the subject, the greater will be the depth of the area in sharp focus. Conversely, the closer the lens is to the subject, the shallower this area of sharpness will be.

3. The closer the lens is brought to the subject, the farther it must be moved away from the film in order to keep the subject in sharp focus. And the farther the lens is moved away from the film, the larger the image will become. This means that in order to get a larger image, the camera must be brought closer to the subject.

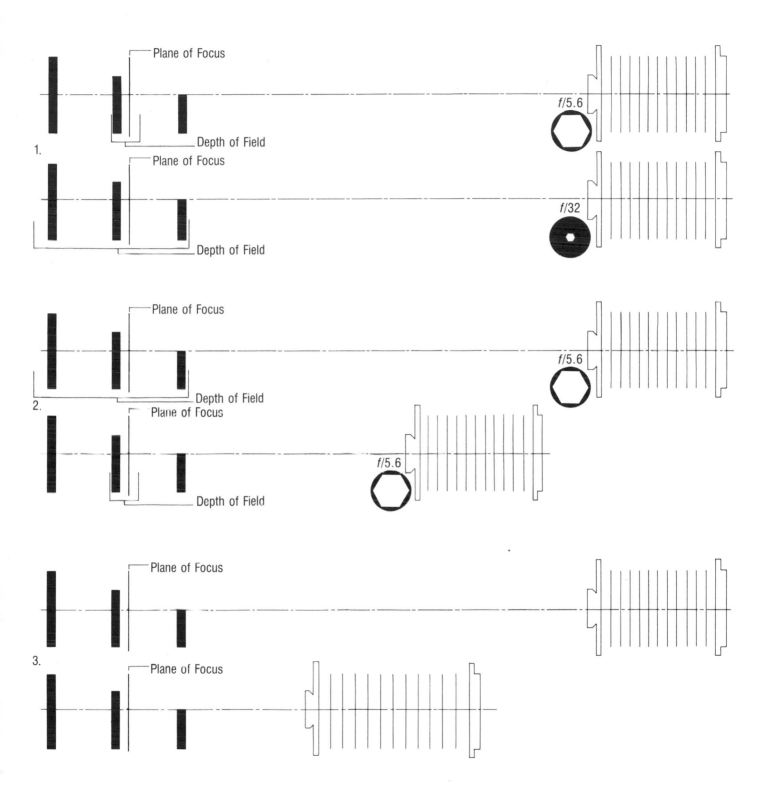

1.

Plane of Focus

Depth of Field

f/5.6

Plane of Focus

Depth of Field

f/32

2.

Plane of Focus

Depth of Field

f/5.6

Plane of Focus

Depth of Field

f/5.6

f/5.6

3.

Plane of Focus

Plane of Focus

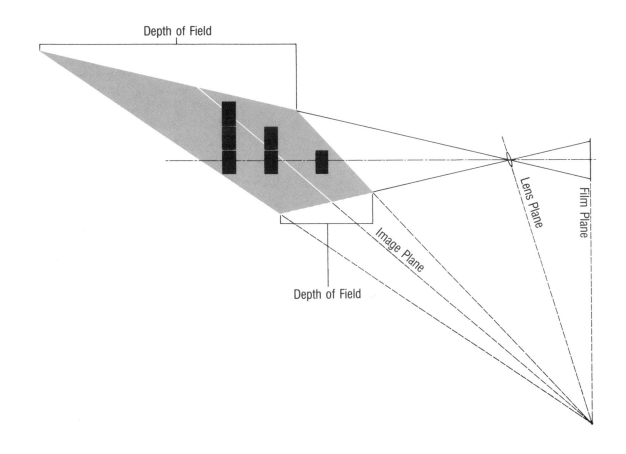

Depth of Field

Depth of Field

Lens Plane

Film Plane

Image Plane

The result of all this is that when the lens is tilted around its optical axis, one part is farther from the film than the other. The part of the lens that is farthest from the film brings into sharp focus the part of the subject that is closest to the camera, while the part of the lens that is closest to the film brings into sharp focus the area of the subject that is farthest away. Consequently, the plane of sharp focus is tipped onto an inclined plane.

Something dramatic happens to the depth of field at this point. The area near the camera remains extremely shallow, while that part which is farther away is extremely deep. This means that the depth of field is wedge-shaped, being thin near the camera and becoming deeper the farther you get from the camera.

By carefully positioning this wedge of sharpness, it is possible to include a vast amount of subject area. Conversely, by positioning this wedge of sharpness correctly, it is possible to isolate a single point in space and have it sharp while everything around it is out of focus.

120

DEPTH OF FIELD AT *f*/5.6

All camera adjustments are in neutral. The plane of focus is the can of clam sauce at the right front. The diaphragm is wide open, and the depth of focus extends from slightly in front of the can to just behind it.

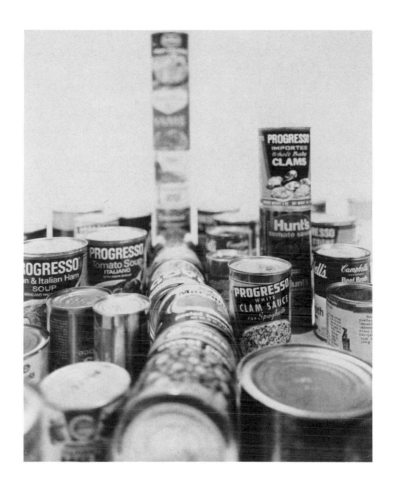

Plane of Focus

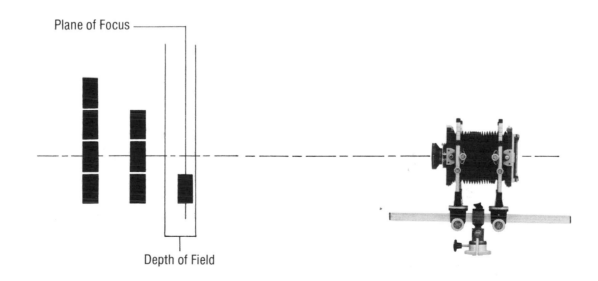

Depth of Field

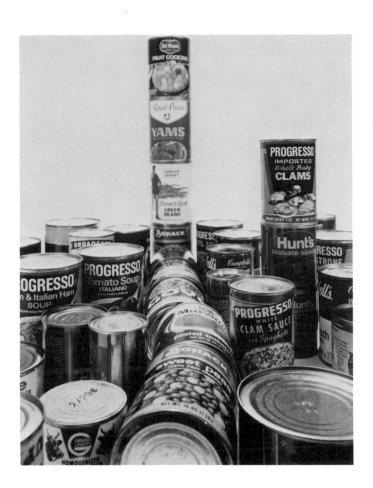

DEPTH OF FIELD AT *f*/32

All camera adjustments are in neutral. The plane of focus is still the clam sauce can at the right front. Now the diaphragm has been stopped down to *f*/32. As a result, depth of field increases dramatically, but the front and rear cans are not completely sharp.

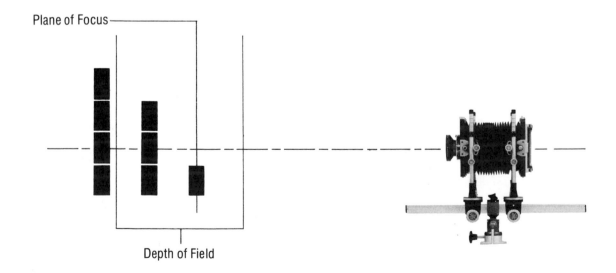

Plane of Focus

Depth of Field

DEPTH OF FIELD AT *f*/5.6 WITH LENS TILT

The camera lens has been tilted downward, so the plane of focus shifts from the vertical and is now inclined from front to rear. The point of focus remains on the can of clam sauce in front. The diaphragm is wide open. Note that the can of milk in the foreground and the can of green beans in the rear stack are now fairly sharp. However, the can of clams in the middle stack has lost some sharpness because the plane of sharp focus has shifted away from it.

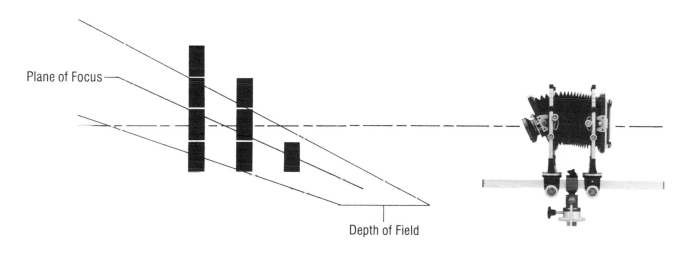

Plane of Focus

Depth of Field

DEPTH OF FIELD AT *f*/32 WITH LENS TILT

All camera settings are the same as on previous page. The diaphragm is stopped down to *f*/32, and everything in the photograph is in sharp focus, even the can of clams in the middle stack.

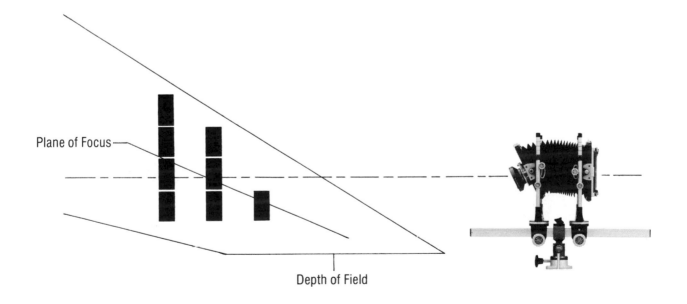

Plane of Focus

Depth of Field

SELECTIVE DEPTH OF FIELD WITH LENS TILT

The camera lens is tilted down as shown on page 123. The plane of focus, however, has been brought forward so it now passes through the top can in the rear stack, the can of clams on top of the center stack, and the top of the can of milk in the foreground.

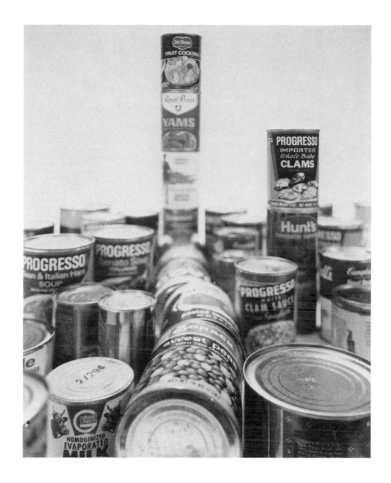

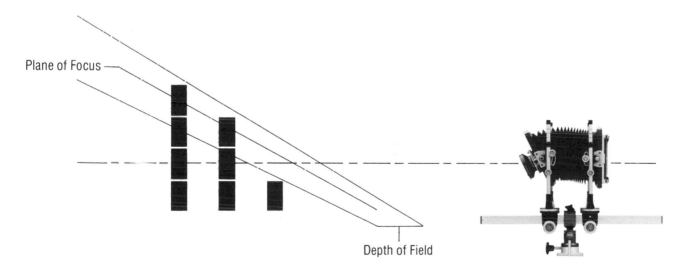

Plane of Focus

Depth of Field

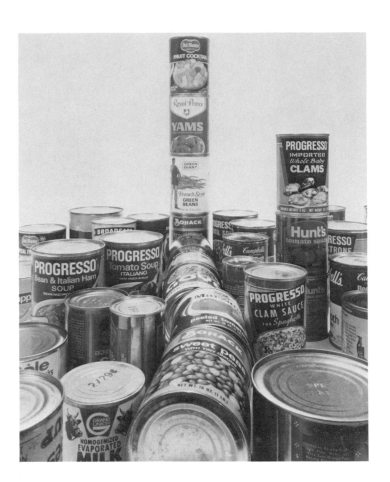

MAXIMUM DEPTH OF FIELD WITH LENS TILT

All the settings are the same as on the previous page. The diaphragm has been stopped down to *f*/32, and everything is sharp except the area at the bottom rear. The can of green beans is slightly soft because it now falls outside the area where everything is sharp. The trick is to place the plane of sharp focus approximately one-third of the way into the area that must be completely sharp. In this way, a small diaphragm opening should bring everything into complete sharpness.

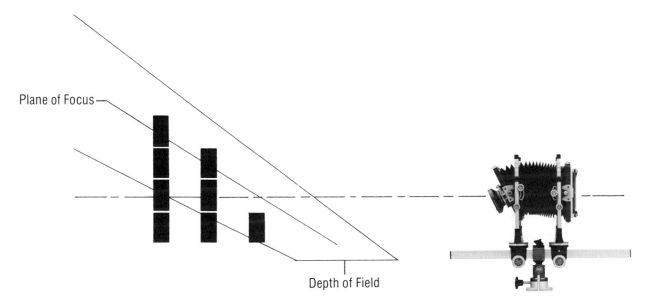

Plane of Focus

Depth of Field

MAXIMUM DEPTH OF FIELD WITH BACK TILT

Now we will control sharpness using the camera back. Bring the lens board back to the neutral position, and tilt the camera back backward, away from the vertical. The result is that the plane of sharp focus is inclined so it passes through the can of green beans at the rear, the lower can of clam sauce in the center, and the top of the milk can in the left foreground. It is precisely the same sharp plane as shown on page 123. However, because part of the back is now farther away from the subject and the other edge is closer than it was, the entire picture has become elongated. As a result, the side cans tip inward and the elliptical shape of the cans in the foreground is exaggerated.

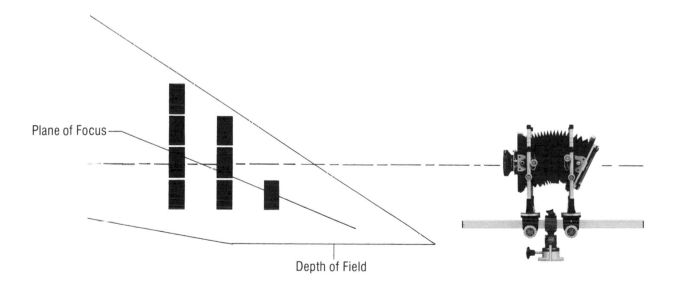

Plane of Focus

Depth of Field